DRAGON AT THE EDGE OF A FLAT WORLD

TURTLE POINT PRESS

BROOKLYN, NEW YORK

DRAGON AT THE EDGE OF A FLAT WORLD

—

PORTRAITS AND REVELATIONS

—

JOSEPH KECKLER

Requests for permission to make copies of
any part of the work should be sent to:

Turtle Point Press
info@turtlepointpress.com

ISBN: 978-1-885983-25-1
ebook ISBN: 978-1-885983-53-4

Library of Congress Cataloging-in-Publication Data
is available from the publisher upon request

Cover photograph by M. Sharkey, defaced by Joseph Keckler
Design by Quemadura

Printed in the United States of America

"Suddenly Seymour" from *Little Shop of Horrors*. Music by Alan Menken.
Lyrics by Howard Ashman. Copyright © 1982 Universal-Geffen Music,
Menken Music and Trunksong Music Ltd. All Rights Reserved. Used by
Permission. Reprinted by Permission of Hal Leonard LLC. "Shave 'Em Dry"
by Lucille Bogan. Copyright © by Munka Music. Reprinted by permission of
Delta Haze Corporation. "Cat Lady" was previously published in *Animal Acts:
Performing Species Today*, "Blind Gallery" in *Great Weather for Media*,
and "Andragon" in *Spunk Arts Magazine* and *Lambda Literary*.

CONTENTS

To Saire and James, for showing me love and art

MY LIFE IS A
HOUSE ON FIRE

When I was three, I watched my house burn down. It was the middle of Michigan winter, after a blizzard. The lights had just come back on after a week-long power outage, and we were all in the kitchen, my mother, father, brother, and I. "I want my dinner," I announced from the high chair. Speaking was not easy yet—words were slippery, swimming in the air like invisible fish, and I had to trap them with my mouth.

"It's coming right up," said my mother melodically. But then there was commotion, and all three of them went tearing up the stairs, leaving me alone for some moments. Next thing I knew, my mother and I were outside. I could see her boots crunching into the deep snow. I was being jostled in her arms and she was carrying me, running speechlessly across a field to the nearest house.

My brother and I watched through the window as flames

enveloped our home, while my parents and firefighters ran desperately back and forth across the blaze like tiny ants. "Are Mommy and Daddy going to die?" I asked, though it now baffles me that I'd already acquired a concept of death, or had learned the word "die." My brother was fourteen years older than I was, practically an adult. He was a smart contrarian and I viewed him as he wished to be viewed—as an authority on all matters.

"Don't be ridiculous," he replied, at once dismissing and assuring me. The blaze became bigger, brighter, wilder. And our home, which I'd always taken for granted, never fully seen before, looked suddenly alive, newly illuminated by the very force that devoured it. Now the fire and the house were one thing.

I remember every detail of that evening—dialogue, images, and sensations. Last Christmas, nearly three decades later, I was even able to draw a floor plan of the house on the underside of a piece of wrapping paper. "Yes, that's right," my father confirmed.

My family believes the fire may have been sparked by a surge, after mice gnawed through electrical wires during the power outage. Or perhaps it started when my father left a space heater too close to a wall insulated by newspapers, though I only heard mention of this scenario once, many years later on a night when my mother was very angry. In either case, the fire spread through the upstairs so fast it hid its own origin. It proceeded to engulf heirlooms, photos, my father's poems, my mother's films. And though my brother had already emerged on the other side of the

eternity known as childhood, he was left suddenly with no record of having had one. Nothing of the house was left standing once the fire finished, no objects were rescued, and some jerk even came and stole our birdfeeder in the aftermath, a detail my mother still shakes her head over. I'm not sure what my possessions meant to me at that age, but now they were gone—a blue-feathered cross-eyed doll called Gooney Bird, for example, and all my little clothes, and the old crib I'd managed to break out of every night. (My first sentence was reportedly "Boy go bed now," but that must have been the first and only time I've actually had the impulse to go to bed—usually I just collapse at dawn like some unholy figure, defeated at long last.)

In the period after the fire, we first stayed with my grandparents, then moved into a rented house with yellow aluminum siding, situated next to the local dump, in a small town nearby. My mother recalls with an amused pity that during this time I began to refer to our life in the house that burned down as "the old days." Though still unable to pronounce my *R*s, at four and five I spoke as if I were an elderly man recalling his prime and the forgotten era to which it belonged.

My parents kept the land the old house was on, a few acres, and called it "the meadow." Throughout my childhood, my dad would take me on trips out to the meadow, which became more and more overgrown as time wore on. There in the tall grass and trees we sometimes discovered curious human objects—a baby shoe, for instance. I wondered if it could have been mine, but

my father didn't recognize it. Who was leading their baby out into our wilderness? It seemed like these lost items were a fruit the land bore. Our expeditions were at once visits to nature, visits to our past, and ritualistic journeys tracing some parallel life in which the house hadn't burned down and this *was* our house, our yard. There were primordial glimpses, too: we walked deeper, beyond the property—though I didn't know where it ended—to a woods and a swamp, where we paid our respects to a formidable snapping turtle that once locked its mouth on a stick my father pointed at it, and would have readily done the same to any finger.

Going back to the meadow would trigger images in my mind, visions of "the old days." Even now, I have a significant collection of infant and toddler memories, which I understand most people lose. I remember, for instance, swatting exuberantly at building blocks my father had stacked up for me to knock down. I also remember slithering under a Chinese rug in the living room and having my mother tell me I looked "as snug as a bug in a rug"—this was perhaps the first time I heard a rhyme, and it gave me a jolt of pleasure. I believe that I remember so much of my life before the house burned down because that time came to such an abrupt halt—the fire obliterated and yet distilled an era for me.

Later in childhood, I developed a savant-like ability to remember sequences of numbers. I could memorize a phone number by seeing it just one time, so instead of going to the

phone book, my mother simply asked me for the number when she had to call the video rental place or Walmart, which she did with surprising frequency. And as a teenager I started imitating the voices of people I knew. To entertain my friends I channeled teachers at school, other kids, odd and beguiling characters I'd encountered. I became the opposite of a celebrity impersonator —I was an obscurity impersonator. As a lively bit of dialogue unfolded around me, I repeated it discreetly under my breath in order to memorize it exactly. Life felt like a story being told to me, something I had to listen to, study, and capture. I became nervously vigilant about keeping lost time alive.

In my adulthood I've managed to make a practice, and a career, somehow, of this nagging need to reconstruct certain episodes from my life. For example, I often write about jobs I've had, as something of an exercise in reclaiming stolen hours, a resurrection of vanishing images. At these jobs most people around me wished they were somewhere else, which, to me, makes the workplace into a ready-made theater of frustrated desire, the eye of a tornado of somewhere elses. I write about people I know. I write about my mother, for instance—or an abstracted version of her—and her ongoing dialogue with her cats. I attempt to critique this dialogue as art, which I suspect it could be, since I know my mother is still an artist, even if she hasn't made much since the fire.

I write, too, about creatures and voices I imagine, and about experiences that quietly shattered me in some way, though they

might appear trivial on their surface. I dramatize certain of these stories and perform them onstage, over and over. So nowadays, I often find myself in some club, delivering an Italian aria, of my own design, about an overdose on psychedelics I experienced years before. Other times I'm singing in a nonsense language I made up, derived from baby talk, about the harrowing final moments of a five-year relationship. Through all this, I keep coming back to what my brother said to me the night of the fire. Every day I wonder, "What is the meaning of ridiculous?"

EXHIBITION

Hello, and welcome to "Invisible: Longing and (In)difference: Nineties to Noughties," at the Solomon R. Guggenheim Museum! I am your audio guide!

This show is a two-in-one, simultaneously a group retrospective of work by contemporary artists who were young in the nineties, and also a generational exhibition presenting new voices of artists who are young now.

(Ding!)

Number One. Emerging artist Leah Cruise's conceptually-based practice encompasses elements of performance and photography, and engages with the digital world. In the creation of this ongoing series, Third Party Favor, Leah logs onto Internet hookup sites such as Craigslist and invisibly mediates conversations. She begins by contacting two people who have compatible, and often extreme, sexual agendas. Leah then engages in two separate conversations, assuming the identities of both parties. She forwards the photos, "stats," questions and desires from one person to the other. She edits nothing, simply acting as the facilitator of— and yet an intervener in—an electronic erotic exchange. Eventu-

ally, if and when a meeting place is determined, Leah drives to the named coordinates and discreetly snaps photos of the initial face-to-face meeting of the pair. From these shots Leah creates the images you see here, silver gelatin prints on pillowcases, which are sometimes saturated in spilt poppers and the artist's own drool.

(Ding!)

Number Two. This is a pile of ashes left when, at the opening, artist Dan Buggins set fire to the previous piece that inhabited this same space, "Impossible Chair" an impossible-to-sit-in chair made by his contemporary, fellow aging Young British Artist Bruce Abel. Buggins, who entered the museum concealing a large can of AXE body spray and a box of kitchen matches, maintained that he was motivated not by any professional resentment, but inspired by works of the past that he admired, namely Rauschenberg's erasure of a de Kooning, and conceptualist Joseph Kosuth's One and Three Chairs.

"I was thinking about the word 'chair'," commented Buggins, "and I simply wanted to create and perform an anagram: I Char. I only wanted to char the chair! But I was apprehended before I could put out the fire at the moment I had planned . . ." Buggins was bailed out by the acquisition money he received from the museum, which added the pile of ashes, now entitled "Sit on This," to its permanent collection.

Some viewers have sat on it, interpreting the title as an actual instruction! That is why the pile of ashes is very small now. The

work, which resulted from the destruction of one piece of art, will itself be erased over time. Just imagine!

(Ding!)

Number Three. The reason the wall is blank and the sign says "audio guide only" is because this piece can be experienced only on the audio guide! You may have noticed a trend in exhibitions to provide as little text as possible, a withholding of information that forces you to spend more money purchasing the audio guide. Well, the Ridgewood collective Rumblebutt noticed this and thought, "Hey, why not deprive viewers of the object itself?" So the object is here on the audio guide. If you haven't guessed it by now, the piece of art is my voice! Rumblebutt purchased my voice saying these particular words.

(Ding!)

Number Four. Now kindly turn away from the exhibit altogether. This is the rotunda. You must have passed through it a few minutes ago. It is populated by your fellow museum visitors, as well as by museum employees. These figures, while alive, tend to be only slightly more animate than the art that surrounds them. Here we see Jessica, slouching behind the admissions desk. She earned her MFA in new media two years ago. Jessica thinks about lunch before lunchtime.

Just a few yards from Jessica is the audio guide station. The audio attendants wear buttons that say "Ask me about the audio guide." But why would you when you've already got me right here?

The newest audio guide attendant is Joseph. His hair is halfway down his back and in a ponytail. He has a glazed-over look. Even if someone did ask him about the audio tour, I doubt he'd have much to say, from the looks of him.

(Zing!)

I moved into a room underneath the elevated JMZ train line in Brooklyn one Saturday night, and began working at the Guggenheim Sunday morning. I curled my fingers around that slippery bottom rung of the art world ladder, the audio guide salesperson rung, for eight dollars an hour. My new manager Nadine, an Australian woman, let me in the side entrance before the museum opened and handed me a stack of glossy fliers.

"All right, mate, we've got a line of people outside, waiting to get in. I need you to bookmark 'em."

What could it mean to bookmark something that is not a book, but a person? To abandon him after splitting him in two with a thin promise to come back later, perhaps? Or could it be a new sexual practice, some thrilling act that previously evaded human imagination? *That's right, I walked in on the two of 'em! They was there on the floor, and they was bookmarking!* No, gentle reader. "Bookmarking," as Nadine was compelled to explain, "is where we stand outdoors, hand each person a flier, and tell them 'Hello. We have audio guides available at the box office.' Can you try that for me?"

Try it I did, five mornings a week for the next six months. I

proclaimed to untold thousands that we had audio guides available at the box office. And that was actually just an odd lie, because there was no box office at the Guggenheim. There was an admissions desk, yes, but it was neither box nor office. Nobody paid me much mind, anyway. Human beings, you see, display a rather narrow range of responses when they are told that audio guides are available at the box office. Very few are *wildly enticed* by this revelation. The great majority of museumgoers I approached did not respond at all, staring blankly past me or even studiously ignoring me. A smaller percentage would huff something like, "I can think for myself, thanks," as though the audio guide were an Orwellian contraption designed to erase their real thoughts and replace them with propaganda. And rarely—just every now and again—some middle-aged woman in a windbreaker would get a glint in her eyes and utter, "Oh, I always do the audio." She would say this with a sense of muted defiance, as though doing the audio were a right someone had tried to take away. I imagined her like a gambling addict, sneaking out of the house twice a week, squandering the family money on doing the audio.

"It's important that we speak to every person," Nadine reiterated to me one day. "I watched you miss nine this morning. And make sure to smile and be persuasive. You're not *convincing* people. Our company has a permanent arrangement with the Metropolitan Museum, but not the Guggenheim. Once we get that contract, we can all relax a bit. Won't that be nice?"

Curious about how this other half lived, I strolled over to the Metropolitan after my shift that afternoon. Sure enough, the operation was more relaxed. It took me five minutes to even find the audio desk, which I finally discovered unmarked and tucked away in a forgotten corner of the vast lobby. A sleeping woman staffed the desk, her hands and face pressed against it, recalling Goya's *The Sleep of Reason Produces Monsters*.

No one napped at the Guggenheim. My colleagues and I assembled the audio gadgets at 8 a.m., as Nadine's right-hand woman Shira, an aspiring commercial photographer fresh out of serving in the Israeli army, stood behind us with a stopwatch shouting "Faster!" as though commanding an underling to propel the Starship *Enterprise* into warp speed. Then, with the urgency of paramedics, we wheeled the devices on rolly carts down the spiraling ramp of the museum. I would sometimes glance over the rail for a quick and vertiginous view of our destination: the empty museum floor below.

Down on the floor we received hordes of patrons who came tottering through the rotunda, flicking sentence fragments at us from yards away. "Coat check?" We transformed ourselves into human racks, hanging headphones from our forearms. Shira manually adjusted our arms if they were not outstretched at precisely ninety degrees.

Scattered across the rotunda was an archipelago of island-desks, each with its own set of inhabitants. Mildly stylish, former art students staffed admissions, exchanging knowing

glances amongst themselves as they listlessly dispensed tickets to the public. Scandinavians oversaw the concierge desk, with the help of one Chelsea gay guy who used to style the crafting guru Martha Stewart before she was sentenced to prison for insider trading. "Once Martha's probation is up, she's going to be bigger than ever, and we'll work together again," he once mumbled, putting his hands together like Renfield awaiting the return of Dracula. At the neighboring desk, the membership headquarters, mysterious figures in business attire took turns disappearing into and emerging from hidden offices.

We, the audio guide attendants, had no desk. We were the occupying force in a foreign land—or were we refugees, squatting on the outskirts of the Info station? Seeing the giant block letters that spelled *INFORMATION* looming above our heads, patrons often approached us with questions. However, we had been strictly forbidden from answering general museum questions, as that was not in our contract, and as, furthermore, that duty belonged to the Info Ladies.

The Info Ladies were a breed of well-to-do New York seniors who worked on a volunteer basis. There were usually at least two of them at a time—these birds did not fly alone. And yet, the desk went unstaffed more days than not. I came to understand that the Info desk existed more as a social club, a see-and-be-seen destination, than an actual service to museumgoers. While the administration furnished the station with pamphlets, exhibition catalogues, and maps, the Ladies often acted put-upon

EXHIBITION

when approached with questions. Their title, after all, did not oblige them to supply information. Rather, they offered something much snappier: *Info*. Frances, a dainty, bejeweled creature, might inform you, for instance, that she'd been invited to a party on Park Avenue but had to decline. "Too bizzy!" she squeaked. Cookie, a butch flâneur not famous for her patience, would tell you her name if you asked, but would be unimpressed if you remembered it, though she never recalled yours. "Yep, Cookie's the name. It was Cookie last week and it's Cookie today." Then there was Thelma. Thelma didn't tell, she showed. Every time she appeared she donned a skin-tight body suit bearing cartoonish images of ropes, whips, and chains—a festive BDSM wallpaper *pour le corps*.

Finally, Florence. Florence didn't have to utter a word for you to know she was Queen of the Info Ladies. By far the most elegant in dress and apathetic toward patrons, she waltzed through the Guggenheim in cream leather pants, wrapped in a cashmere shawl, with her platinum sculpted bob and long burgundy fingernails that radiated their own light. But Florence needn't even stand at her Info post for you to understand her to be the most refined fashionista and chaste Info-giver. Eventually emancipated from the desk, Florence passed into an upper echelon, floating out into the Info-sphere. She became like Yoda after he died, acquiring the privilege of metaphysicality, just appearing, oh, here and there, as a hologram; you see, at a certain point Florence stopped coming in for her Tuesday shift. Thelma and

Cookie took her place behind the desk. And yet: Florence still breezed into the museum every Tuesday, still walked to the Info desk and proceeded to chit-chat with the other two ladies, remaining the entire time on the other side of the Info desk as though she, having come full circle, were now an Info-*seeker*. As actual seekers approached, Florence just smiled and checked her nails, allowing Thelma and Cookie to fend off the seekers on their own.

I am Florence, Patron Saint of Info Ladies. I am named after that city which is home to 85 percent of the world's art treasures. That is naturally why I was given my job at the Guggenheim. I was appointed. To understand what Info is, you must understand what Info is not. Info is never an answer, dear—Info is an attitude. Info may change. Something that was Info yesterday may very well not be Info today. So go ahead, ask me anything you want. Just remember: I may point you toward the exit, but you must find the elevator on your own.

While bookmarking outside, I was always on the lookout for intriguing New Yorkers. Back in the Midwest I had striven to put myself under the tutelage of the sophisticated and eccentric, and I figured pickins might be better in NYC—taste, intellect, and excessive peculiarity were celebrated here, so the old story went, in contrast to regional America, where such qualities are generally regarded with suspicion and contempt. I wanted to learn how to become a New Yorker. I wanted to become an artist, too, though I struggled with what kind of artist I should be. In

school I had made a series of self-portraits in oil, sometimes channeling Romaine Brooks to envision myself as a wan dandy, other times painting myself as two green figures, one man and one woman, with a sense of some unresolved relationship. Often I affixed a color copy of one painting to a different blank canvas so it looked like another real, and identical painting. I had also been constructing installations using the hair of strangers, writing monologues, and training as an opera singer. Was I setting my sights on becoming a human *Gesamtkunstwerk*? Did I wish to be too many things at once, or did I scamper from one mode to another in order, really, to become no one? Was I simply a fringy dilettante?

As pressing as my aesthetic questions may have been, today there were unavoidable matters of survival on my mind as well, and I was beginning to feel increasingly desperate. For groceries, I could afford only eggs and ninety-nine cent loaves of white bread. To make life a touch grimmer, a junkie had just ransacked my apartment under the J train, after removing the door with power tools, and I'd had to take a day off of work to clean up the mess. So under the auspices of selling audio guides, I began trying to establish connections and make friends in the hope that someone would recognize my—well, whatever was good about me—and would, in turn, impart some great cosmic knowledge to me, or at least hook me up with a slightly higher-paying job. First, I tried to imbue "We have audio guides available at the box office," with élan! I tried to invest it with pathos,

even, drawing on my operatic training. *The body is the instrument*, I'd repeat silently, taking a deep breath. This delivery soon proved ineffective and unbecoming. So I then decided to adopt a more detached approach, adding a dash of irony to my tone in order to represent the public's doubt about the product and give myself credibility. Now, when some grumpy patron spat, "I never do the audio," I took to lowering my chin to diabolically whisper, "Neither do I." And all the while, bookmark to bookmark, I was waiting, like a cannibal for an anthropologist, to be discovered.

One brisk and sunny November morning I was sent out to bookmark the line. I pursed my lips and blew visible breath as though it were smoke. *Ah, to be young in every decade and not just this one!* I waved to the hot dog vendor and the woman who sold faux African masks on the sidewalk and began making my way down the line. Then I saw him, a dignified older man. He was wearing tweed, sporting a neatly trimmed white beard, and his cheeks were round and rosy like polished holiday apples. He reminded me of Santa Claus, but more clean-cut and tastefully dressed. As he inhaled, his chest expanded, bulging out of his jacket like the swelling breast of a large bird. A big metropolitan rooster, he announced the morning into his cell phone. "Why, yes, it's just beautiful here in New York." His voice was deep and clear and his enunciation was as crisp as the air.

I was gripped by an uncanny sense that I should know this man. He brimmed with intelligence and warmth. He might be a

famous radio announcer, literary critic, or host a program on PBS. Walking over to him, I toned down my spiel. "We have audio guides available at the box office," I said with gentle assurance, as though I were a kind nurse informing some husband that his wife was in good condition after a kidney transplant.

"Why, thank you," he replied, appearing genuinely grateful. Our eyes met briefly. I smiled and moved down the line.

Twenty minutes later, as I crossed the rotunda to retrieve more bookmarks, I heard a low voice behind me. "You convinced me," it said. I turned around to see the Santa-man grinning benevolently with a pair of headphones around his neck. He raised the audio device into the air, as though to toast me.

"It must have been my pitch . . ."

"It was pure poetry." With that, the Santa-man disappeared into the exhibit. He had seen something in me.

"Returns!" came another, markedly less mellifluous, voice. I turned to see Shira. She was pointing, like the Ghost of Christmas Yet-to-come, across the rotunda toward the area where we collect units from people exiting the exhibit. I remained at this station for the next hour, facing an onslaught of tangled audio guides. I couldn't collect them fast enough. The cords of one family's audio guides had woven themselves together into a Gordian knot. A father, son, and daughter were entangled and when I tried to help I got tangled up too. As I struggled to free us all, I felt a hand slip something into my back pocket. The Santa-man's voice came whispering from behind.

"I'm going to a party this evening. The address is on my card. Oh, and no need to change—just come in your work clothes."

At 6 p.m. I defied the Santa-man and took the hour-long train ride back to Brooklyn to change, since I did not want to wear my little audio apron and dingy blue button-up shirt to my first fancy New York party. I put on a black sweater and the shiny black pants I had bought for my job interview. I'd pragmatically left the tag on, tucking it inside where it had scraped my right buttock. Boldly, I now tore the tag off. I massaged some Chap-Stick on my scuffed shoes and ran out the door.

By the time I stepped off the train in the East Fifties, the air had become unseasonably balmy. The card the Santa-man gave me just had a name on it, with no title, as though he were his own title. I kept glancing down at his cursive numbers as I scanned street addresses in search of the building. I eventually spotted Santa waiting in the entrance to a high-rise. "Hello, friend!" He waved and beckoned me. I glanced back at the card. *Frank. Santa's name is Frank.* I followed Frank past the doorman, who smiled and nodded.

We got into the elevator. "My friend is the Omani ambassador to the United States," Frank said. "Now when we get up there," he continued, pressing button "42" with his chubby thumb, "I'm just going to introduce you as the son of a business associate of mine—sound good?"

"OK," I said. As the mirrored doors pulled shut, I watched myself agree to this proposition before contemplating it. *Why*

would Santa…? I reasoned that the ambassadors might be puzzled if Frank were to tell them the real story of how we became acquainted—they wouldn't understand that startling yet warm sense of recognition that struck both of us—and how could they? It's such a rare and inexplicable experience between strangers. And what business does an audio guide salesperson have at a United Nations cocktail hour?

Frank led me into an enormous room full of well-dressed people. Swarms of servants attired in classic maid and butler uniforms moved about in zigzags, passing out plates of food and snatching up empty ones. "Oman is known for their silver work," Frank remarked as I viewed my distorted reflection in the goblets, platters, ornaments, and weapons that filled cabinets around the room.

"Hey! Didn't I meet you at the last one of these things?" a woman in a dashiki asked me, wagging her finger at me and grinning.

"Of course you did!" Frank answered quickly, just as I was opening my mouth. *She sees me as belonging*, I thought, pleased.

Frank guided me to another part of the room, then took me on a tour of the apartment, while continuing to give me tidbits about the culture of Oman.

The host, a small dapper man, introduced himself to me.

"Welcome to our end-of-Ramadan feast," he said, wiping a crumb from his black moustache with a cocktail napkin.

"The feast after the fast," Frank added, whisking me away

EXHIBITION

from the ambassador. I felt a pang of guilt for being admitted to the feast without suffering the fast. "Now come with me," Frank said softly, "I want to show you something really beautiful." I followed Frank to a second elevator, the likes of which I'd never seen, as it was an elevator actually *inside* the apartment. The elevator took us up, past the servant quarters, to the top floor, where Frank and I stepped out into an enormous room—a room without bounds. The room was New York City itself: its walls were glass.

Taken with the Brooklyn skyline, I pressed my hands, still oily with cherry ChapStick, against the glass. The only time I'd been high up like this was once when I visited the top of the Empire State Building on a trip, but all I could ever remember about it was the chain links that caged me, keeping me from chasing the imp of the perverse over the edge. Now I exhaled onto the glass: in an instant, fog covered the East Fifties.

"Which bridge is that?" I asked. There was a moment of silence, followed by a warm breath in my ear.

"Queensborough," the Santa-man whispered, making the word sound like a term of endearment. His tongue followed, snaking around my outer earlobe and burrowing into the hole. I felt his hands grip my waist as he greeted me again. "Hello, friend."

"Come," Frank said, directing me toward a bed that I barely noticed was in the center of the room. I paused, then proceeded stiffly toward it. He moved his hands over my clothes, and then

EXHIBITION

under them. "Does this feel good?" I nodded blankly, in the manner an amnesiac might if he'd been asked a question about himself and were guessing at the answer.

As Frank reached for my belt buckle, I reckoned with the thought that this event was, no doubt, what he had in mind ever since I told him about the audio guide at 9 a.m. Of course it was. And here I was, being peeled out of my shoes and fancy pants in the bed of a diplomat. I opened my mouth to say something. The words *wrong impression* and *sorry* weighed in my throat like coins. But Frank was already on all fours with his shirt unbuttoned half way. He was breathing fast and his breath smelled like broth. My face fell onto the comforter, which was impossibly soft.

I must admit, I was simply not attracted to male seniors. Perhaps I was not attracted to "men" at all, really; I seemed to like boys my age, with long hair, who carried forth some inexpungible sense of juvenility and delinquency, and girls who skewed lesbian and wore tight clothing. Might I pretend Frank was one of these? I closed my eyes and tried as his beard scraped against my thigh.

Retreating into my mind, I remembered similar incidents from my past. Did I conceive of my body as a musical instrument that belonged to no one in particular—banged up and out of tune, the property of some hospital's activity parlor, available for anyone to pick up and strum a vulgar ditty on? I once let a very unwashed urban nomad girl whose mind I admired have

her way with me. I wasn't feeling it, but it felt like a small price to pay to hear a few more pearls of her drunk wisdom. And then once in a Traverse City karaoke bar some clown named Larry busted into a bathroom stall and grabbed my urine-spurting penis. I was slow to respond, failing to say, "Hey, stop that!" because I was fascinated by his brazenness.

Frank was now pulling down his pants, still panting.

I wondered if I might lack what are popularly termed "good boundaries." My father perceived this when I was little—he was troubled watching me at age eight out on the soccer field: I was lolling around back by the goal post, looking up at the sky (to find shapes of creatures in the clouds, of course) and never looking at the soccer ball. He called me to his "study," a messy uninsulated room in the corner of the house, to have a talk with me about protecting my space in the world. But I showed up to our meeting wearing a green tinsel wig, leprechaun hat, and sunglasses, with a holster around my waist. I drew a microphone from the holster and held it to my father's mouth, as though interviewing him, as he tried to make his points.

I did have boundaries, I realized. They were hard, cold, and invisible like the glass walls of this room. It may appear that I do not belong to myself. In fact, I view myself not as a person but as a place, or more precisely, as a trap. *Frank walked into my story and he is my captive, haha!* I thought, a new sinister air gathering around me as I lay on the bed, now receiving Frank's attention with all the erotic gratitude of a twitching cadaver.

"This . . . feels a little forced," Frank said, finally pulling back. His face, crimson from the sexual rush, changed to a rouge of embarrassment.

We put on our clothes and got back into the elevator, each carrying our own special disappointment. I bid farewell to people I had met on my way to the door. "See you next time," I waved to the woman in the dashiki.

"You better!" she hollered, laughing.

Frank walked me out of the building. The air outside had become strangely tropical. We strolled down the street for a while, silent, in the dark. Occasional bodegas cast a sickly glow on the sidewalk.

"What did you think when we met?" I asked suddenly, surprised to hear the words come out of my mouth.

"Well, you . . . ," Frank responded, eventually, "told me about the audio." Struggling to come up with something more to say, he added, "and you were very pleasant." In my innocence, or was it staggering arrogance, I had imagined he'd been as struck by me as I was by him, and that he might report that he'd felt as though he were being offered an audio guide by some figure outside of the ordinary—a baboon, for instance, Audrey Hepburn, or a poltergeist. "Then of course there was the look."

"The look?"

"Yes, the look that made me know we would be . . . ," he glanced around and lowered his voice, "compatible."

A look. Was there such a look? I asked myself. Was I unwittingly speaking in some arcane code? Might my irises be flashing these "looks" all the time? Perhaps I was like the Marvel Comics character Cyclops, who must wear special goggles to prevent lasers from shooting out of his eyes. Perhaps my wild peepers were firing off lust beams, willy-nilly, leading to misunderstandings left and right. Maybe bedroom eyes were the only eyes I had? Maybe my way of being in the world was essentially flirtatious.

I entertained such possibilities. But in truth, Frank and I simply misread one another's interest. I had conceived of him as a Socratic, high-culture grandfather who wouldn't likely be cruising at the museum before noon, and he had envisaged me as a bushy-tailed audio tramp.

"Goodbye," he said.

"Goodbye," I replied, reaching out my arms to give him a hug. He did not hug me, and seemed to feel damned by the mere invitation, looking nervously around to see who might be watching us.

The next day was slow at the Guggenheim. Nadine had called in sick, though I knew her to be a good-time gal and imagined she simply had a later and wilder night than I. Thelma and Cookie stood behind the Info desk. "How are you?" I asked them. Thelma simply nodded her head, brushing a wrinkle from her de Sadean romper.

"I'm fine!" snapped Cookie. She said this as though I kept offering her a blanket when she *wasn't cold!* Thelma gestured towards me, as to perfunctorily ask *and you?*

"I'm fine," I replied. "I went to my first New York party last night. At an ambassador's house." Cookie raised an eyebrow. Just then I heard the sounds of rustling. Suddenly, up rose Florence like a swan, between Thelma and Cookie, with a stack of Frank Lloyd Wright brochures in her hand. Miracle of miracles: she had resumed her throne behind the Info desk.

Florence set the stack on the counter and straightened them with her long nails. "An ambassador's house?" she asked, turning to face me. "Well go on, dear. Sounds interesting." She gestured, like a teacher, calling on me for an answer. "How did this come about?" she pressed. "We want *details.* Don't we, ladies?" Thelma and Cookie didn't respond, but continued to flank Florence, like absent-minded backup singers. I knew she wasn't the type to humor anyone or express interest if she hadn't any—clearly, Florence believed that I had Info.

All around us I heard a soft crackling of voices, barely audible remarks concerning art objects, emanating from the many visitors who moved in processions along the spiraling ramp above us, having no choice but to circle the museum's empty center. Round and round they went, like senile birds of prey. Florence lowered her chin and whispered, "I want to be *transported.*" The word ricocheted through the rotunda as I opened my mouth to speak.

EXHIBITION

BLIND GALLERY

My friend gets a travel grant and leaves town. I take over some of her shifts, working for a blind gallerist on the Lower East Side. He's not one of those blind people who you forget is blind. He won't let you forget. He begins every few sentences, "Now, I don't know if you know this, but I'm blind . . ." He is very erudite and with-it and his friends are always coming over to read him art reviews, *The New York Review of Books*, new poetry, new literature, on and on. But if you are me and you ask him, "Say, did you read the such-and-such article in *The New Yorker*," he'll reply, "See, the thing is, Joe, I'm *blind*." Choking on laughter, he adds, "Can you imagine a blind motherfucker like me reading, uh, *The New Yorker* and some shit?"

My boss speaks through his teeth with a sense of strain and release, as though he is always simultaneously inhaling or exhaling a hit of pot. A breezy and hip walking bass drifts perpetually from the stereo behind him. He has a phone next to him and he makes calls all the time. But if the phone rings and I pick it up and it's for him and I turn to him and say, "Hey, so-and-so is on the phone," he replies, "I can't talk to him. I'm blind! Tell him I

can't talk. He'll understand—he knows I'm blind." Sometimes my boss takes naps in the middle of the day. Sometimes, when the phone rings, he wakes up and picks it up. Yawning, he whispers, "Yeah, I'm in meeting right now. Mmmm, bye." When I ask him how he curates shows he mutters, "I got people I trust. I rely on their opinions."

I am quite diligent the day I start. Because my boss cannot monitor me—not visually, anyway—I don't feel rebellious like I do at other jobs. On the contrary, I feel a sense of honor and responsibility to take care of business with efficiency and care. When my friend calls him from out of town to see how things are going my boss says, "This Joe motherfucker is professional as shit. That motherfucker is PRO. FESH. UH. NAALL!" He deems me to be so professional that he soon decides to hire me on for a while. Even after my friend comes back to town. I work shifts on the days she doesn't.

I have forgotten to mention that my boss's gallery is in his apartment. He sleeps on a couch in the living room. In the morning he wakes up, sits up, and swivels his body, placing his feet onto the floor. The setting transforms around him: magically, he is at work. Interns began flooding in. Well, one intern. "Is fatso here yet?" my boss asks.

"No, not yet," I say. "She's not fat," I add, thinking that he might not know, since he is, after all, blind.

"Yeah, let's give fatso a call," he replies with a grin. "Let's get

ol' fatso on the horn. See when she plans on, uh, rollin' on in here."

I have various duties. Sometimes I handle development. *Joe, can you call this rich motherfucker and see if he'll wire some money into our account?*

Other days I oversee marketing. *Joe, could you, uh, order a bike messenger? See if he can take this postcard invitation to our next opening up to Yoko Ono? I just heard on the news that she's back in town.*

I also work in programming and one day my boss has a special mission for me. "Joe, listen. This friend of mine, a poet, uh, passed away." I nod solemnly, though my boss can't see me. "I mean this motherfucker just *dropped dead*," he continues. "So, uh, some of us are going to put on a memorial reading and we need a venue. I'd like you to go over to the XYZ Bar tonight and look into how we can book a reading. We just want to read some of this guy's poems since he just dropped dead on us, see." He feels around on the table for his checkbook, opens it, and scribbles out some numbers and loops. "I'll pay you an extra hour," he says, tearing out the check and handing it to me.

"Oh, thanks," I say, tucking the check in the right pocket of my jeans.

"I'd go over there myself," he says. "But, you know . . . I'm blind."

First I try simply to find booking information on the website

of the bar, which I know to be a downtown destination of NYC literati. There are no instructions, just a phone number. I dial it. Nothing. So after leaving the gallery that evening I walk to the bar.

I climb a tall flight of stairs up to the second floor. I enter a dimly lit room. The air smells sick and sweet—the floor and tables are breathing into the room the stale vapors of years of spilt beers. A distorted, grungy bass line plays repetitively on the PA. A modest number of customers line the room, leaning against walls with their drinks, chatting in corner banquettes. The center of the room is empty.

A woman with messy jet-black hair sits at the bar, hunched over a half-drunk martini. She's got an unlit cigarette between her fingers. She conducts the air with it as she talks to the bartender. Occasionally she absent-mindedly draws it to her lips, before glancing downward and seeming to silently remind herself that in New York these days you can't have it both ways: no smoking inside, no cocktails on the street. I sit down at the bar, one seat away from her. The bartender is slender with a long ponytail.

"What you want?" he asks me eventually.

"Hi," I reply cheerfully. "I actually just came in to get some information. I work for a gallerist, a blind gallerist, who is trying to organize a memorial reading for a friend of his—a poet who just passed away—and I need to know who I can talk to . . . about booking. A reading."

"Yeah?" the bartender says, lifting his chin, "Well I'm such a fucking bartender that all I can do is pour a drink." He turns and walks away from me.

"Can I get a gin and tonic?" I ask.

"Five," he says. I slip him seven.

"So is there a number or an email address that I can give to my boss?" I ask, adding, "I would really appreciate whatever you have." The bartender reaches for a book of matches, and tosses them at me. The XYZ phone number appears at the top.

"Thank you," I say. "But I already dialed this number and there was no . . . info . . ."

"Give it up!" The black haired woman laughs, tapping the filter of her unlit cigarette. My eyes follow imaginary ashes as they fall from the end of it into her now-empty martini glass. The bartender snatches up his shaker and refills her drink. "You're not going to win. Can't you see that?"

"Win?" I repeat. "I don't need to 'win.' I just need to book the reading of a dead man's poetry. My boss would have come himself, but he's blind! You are such a 'bartender', I understand that," I say, raising my voice as the bartender moves into the storeroom, out of sight. "And I bought a drink from you. Now can you please let me know who I can talk to?"

After several moments the bartender reappears in the darkened opening of the storeroom. "Leave," he says. "You leave now."

He's got a vodka bottle in his hand. The woman leans on the

bar with one elbow, and swivels to face me with a crooked smirk, twirling her now limp and wrinkled cigarette as though she's flashing a weapon.

"I'm not leaving," I declare. I am emboldened by duty, and also by gin. I am not here for myself—not here on my own time, my own dime. No, I am *on the job*. *On the clock*. The setting of work surrounds me like an aura. Furthermore, I am here as a representative of the dead and the blind. "If you want me to leave, you'll have to call the police and see if they can make me. I'm going to sit right here."

The bartender slams the bottle down. He reaches under the bar and presses a button. The music stops. Every head in the bar turns toward him, toward the two of us. He waits for a hush to come over the meager crowd before pointing at the door and shouting, "Get out now!"

I pretend not to have heard him. I become totally still. I say nothing. I just sit in my stool and stare blankly at the bottles in front of me. They are assembled in tiers, a Roman senate of psychoactive beverages. The bartender picks up the vodka bottle. He walks out from behind the bar. He unscrews the cap. He takes a swig: he spits it at me. It soaks my right shoulder and stings my neck. I don't move. He takes another swig and spits it at my face. I close my eyes. He circles me clockwise, continuing to fire eighty-proof loogies from every direction. Some people are watching but no one reacts.

Leaving the bar is not an option I consider. But how can I ex-

tract myself? I can't allow this bartender to assault me with whatever items he has on hand. Is there someone I can appeal to here? As another jet of burning liquid grazes my left thigh, I instinctively slide my hand into my pocket in order to protect my cell phone. Suddenly it occurs to me—I could transport myself out of the bar without leaving. I pull out the phone and dial.

"It's Joseph. I am at the XYZ Bar."

"Oh yeah, Joe?" replies my boss, with a rasp. "You figure out how to get this memorial going? Tell 'em this guy just *dropped dead.*"

"The bartender is spitting liquor on me," I state.

"Oh yeah? Spittin' on you? Well, Joe, those motherfuckers over there are crazy. That's all right. We don't have to do it over there. We can do it over at, uh, Saint Mark's."

Now that this pronouncement has been made, I no longer have business here. I return the phone to my pocket, turn, and walk with matter-of-factness out the room, down the stairs, and out the door onto East Fourth Street.

I wander around the East Village, which is quietly bustling, alive with crepuscular chatter. I stop intermittently to sit on the stoops of strangers. I cook up plans. Revenge plans. *Maybe I could return to the bar with a Super Soaker squirt gun*, I think. *That'd learn 'im. And with which liquid might I fill it?*

As the night air dries the liquor and saliva from my skin and clothes, my rage wanes. Eventually I resolve simply never to darken the door of the XYZ again.

BLIND GALLERY

The next morning I wake up. I reach over and pull the check my boss gave me out of my jeans. The numbers he wrote were already jagged and wild and now they're blurred from vodka. But they're still legible. I walk over to the bank. I deposit that check. It bounces.

CAT LADY

"I am *not* a cat lady," my mother declares, a bag of Whiskas under her arm and a Maine Coon at her feet. She marches through the laundry room to answer the lament of a portly calico who is kept locked in the pantry. "No, you stay out here, Don Diego," she cautions the Maine Coon. "Mrs. Gummidge has yet to reconcile herself to other cats. Thus she remains in self-imposed exile here in the pantry." My mother manages to slip into Gummidge's chamber without Don Diego. "Well, Gummidge. You didn't finish your white albacore. Why didn't Gummidge finish her white albacore, pray tell?" She directs the question to the calico, while referring to her in the third person—the way, in *Batman*, that Alfred speaks to Bruce Wayne. *Master Wayne wishes not to entertain any guests this evening?* "Gummidge desires that I take this tiresome tuna away, and present her, in its stead, with some fresh Whiskas—or perhaps some Science Diet? Yes, Gummidge need a new snack." She moves from butler talk to baby talk. "Gummidge finished with dat tunie. She done."

My mother emerges from the pantry, the china plate of abandoned albacore in one hand, the now slightly lighter package of Whiskas in the other. She is wearing a calf-length pink cotton

skirt and a discarded t-shirt of my brother's that bears, down the front, the word "paranoia" six times. Her hair hangs down to the middle of her back. Though it is gradually becoming more and more white, for years it was a deep copper, with just two silver streaks that framed her face. The streaks had been a lineament of her icon in my childhood; several of my classmates had believed her to be a witch, citing the strange strands of silver, symbols of age that stood in contrast to her still-youthful face. My mother has some wrinkles now, but her lips remain overly full, defiantly young. Only months ago, a Walmart one-hour-photo clerk mistook her for my wife. She is an age chameleon.

"Sit down, Carol," she says to my aunt, the sister of my father, who waits for her in the kitchen. "I'm just going to run upstairs and quickly change."

"Take your time," Carol calls.

My mother is usually an obsessive hostess, assaulting guests with hot chocolate and pillows, items of sustenance and comfort. But Carol comes over almost every day now. She is slender, with recently bleached blonde hair, and red lipstick. She had once embarked on a Broadway career, but aborted it, opting to marry and raise a family. Still, she is revered by community theatergoers throughout the greater Kalamazoo area. Her husband, Terry, recently had an affair with a local country western singer named Debbie. He is now divorcing Carol. She has taken to self-medication, sometimes preparing cocktails of vodka and various anti-anxiety pills.

My mother returns in a purple skirt with intricate black designs, a luminous gold short-sleeved shirt, and alligator boots. "Want to visit Gummidge?" she asks.

"Oh, not right now, Kit," Carol replies. "In a bit, though. I'll see plenty of her."

Carol has agreed to help my mother take Mrs. Gummidge to the vet's this afternoon.

"She's awfully forlorn, you know," my mother says.

A one-time filmmaker, poet, mixed-media artist, and high school English teacher, my mother has not created work since our house burned down in the eighties, destroying her reels, assemblages, and manuscripts. Since that time, she has, however, devoted herself to the 24-hour-a-day interactive performance/installation of caring for, dominating, and dramatizing the lives of cats. While critics, historians, neighbors, and the mailman all classify this piece as quintessential Theater of the Cat Lady, my mother often entitles it *I Am Not a Cat Lady*. This could be understood as a surrealist strategy, akin to that which Magritte employed in his painting of a pipe with a caption that reads, "This is not a pipe." My mother, the Cat Lady Who Is Not, wishes to keep her relationship to the cats unexplained.

My mother summons the void in her baby talk to cats. A militant grammarian, she is prone to suddenly deny her understanding of subject/object and past/present, affect a speech impediment, and recite Elmer Fuddian incantations. For example, I remember once doing my middle school algebra assignment at

the kitchen table, in the company of my mother and our cat, Cubby, a former stray with one ear who bore a remarkable resemblance to a baby bear and taught himself to sit up and beg and wave for treats, play fetch, and other circus bear tricks. As Cubby blankly watched my pencil in the erratic movement of equation solving, my mother announced, in baby talk, "Cubs don't do 'rithmatic! No. Him don't do no '*rithmatic*." She pushed her lips out in a half-pout, half-kiss, tensing her mouth. She spoke in spite of the tension. "Himm dona doo no '*riffmatick*," she repeated insistently. She chanted the phrase over and over, distorting the words more and more each time, pursing her lips more intensely; she spoke as if she simultaneously wanted to *be* Cubby, make out with him, and eat him. *Just gobble him up.* She would have cuddled with him if she could have been sure she wouldn't have let herself go in a moment of Lenny-like over-exuberance. Instead, she cuddled, morbidly, with language itself. As Warhol dissolved the aura of celebrity through his serial representation of famous faces, as the Marquis de Sade used his characters' repetition of criminal and perverse acts to purge the acts of their meaning, so my mother, through repetition, flushed all the logic out of the fact that a cat can't do math.

"Don Diego is named after Zorro's alter ego, a dandyish fellow that nobody ever suspects of being Zorro," my mother begins to explain to Carol, apropos of nothing in particular. "Why, no one would imagine, while watching *our* Don Diego in the pantry, daintily nibbling on his Fancy Feast, that when he ventures into

the yard, he becomes a virile and mysterious hero. Mrs. Gummidge is named after the widow in *David Copperfield*. Our Gummidge also weeps, perpetually, in her own plaintive mew."

The Dr. Moreau of interior decorating, my mother sits among strange mixtures of animal prints, in her dark laboratory of excess. Zebra print pillows populate the sofa, a deep-orange leopard rug spreads across the living room floor, and peacock feathers peak out from the ceramic Chinese umbrella holder. The alligator boots my mother has put on her feet are the variable in today's experiment in hybridity. She strokes Cleopatra, the chubby Siamese who sits next to her, on one of the five luxurious cat beds in the living room.

My mother continues to psychoanalyze the cats as Carol nods quietly and smiles her actress's smile, the corners of her mouth rising high up on her face, only to turn slightly downward at the last moment—like a firework streaking up to the sky and failing to explode.

Carol is afflicted with Sjögren's syndrome, a rare condition that makes one unable to produce tears. When she cries, she must squeeze drops of saline solution into her eyes. In life and on the stage, Carol is an actress incapable of summoning tears. She often arrives on the porch, Visine in hand, coming to present my mother with a new plot to sabotage Terry—or win him back. "Kit, I've got it. We can plant a camera in his apartment, and catch him, *in the act* . . . Or maybe I should just write him a long letter, tell him that I love him. What do you think?"

CAT LADY

Carol brings plans to my mother like densely tangled knots. My mother carefully unties each one. While my mother frequently talks Carol out of her outrageous plans, she sometimes trumps Carol with machinations of her own. Several weeks ago, enacting a plan of my mother's, the two broke into Terry's office in the middle of the night to steal financial documents.

On Carol's more manic days, she greets my mother on a sustained pitch, at the top of her rich coloratura soprano, and the two women exchange operatic dialogue for a few moments, before Carol goes careening into an aria about the tawdriness of Terry's mistress. "That Debbie is a sluuuuuut!" she shrieks.

Carol talks about the divorce obsessively. She puts on an exaggerated Southern accent, referring to the upcoming hearing as *my trial*. "Aw, Kit, you gotta come tuh mah trah-uhl, and testifah! You can say: Wha ye-es, Ah saw them two—togethah!"

Today, though, Carol is subdued—not despondent and not at peace, just still. Well acquainted with the cast of cats, she does not mind listening to my mother's stream of anecdotes.

"I don't know what to do with Gummidge," my mother sighs, rising from the sofa. She walks to the antique cabinet across the room. It is an heirloom, one of few that survived, having been in storage at the time of the fire. "She's sick. Moaning all the time. I think we're making the right decision, taking her to the vet's," she says.

"Yes," affirms Carol. My mother draws a silver Jacobson's department store box from the cabinet. She sits back down and

opens it. It is filled with photographs of cats. My mother is not a linear person, and the images are not organized chronologically.

My mother shows Carol pictures of Little Fox, the cat to whom she used to sing her original lullaby, "Cuddle Cats," in retaliation against my father's saying he abhorred the word "cuddle."

> *We're just a couple of cuddle cats, cuddling all day long*
> *We're just a couple of cuddle cats, that's why I'm singing*
> *this song*
> *Cuddling, cuddling, cuddling all day long*
> *Singing, singing, singing our cuddle cat song*
> (Repeat indefinitely)

My mother shuffles past a black-and-white photograph of a cat that catches Carol's eye. "Which one is that?" Carol asks.

"Hmm?" my mother hums.

"The gray one," Carol says. The cat appears to be gray, but as the picture was taken in black and white, in real life the cat could have been orange, deep cream, or pale brown.

"I don't want to talk about that one," my mother says, abandoning her gentle, nostalgic tone.

"Why not? What's his name?" asks Carol. My mother speaks a Z-word name that Carol forgets immediately. Then she pauses, and inhales slowly through her nose.

"My second husband was a painter with an ungovernable

temper. He used to come home and throw his paints against the wall. One night he came home and threw that cat against the wall."

"*He killed it*," Carol gasps. My mother silently returns Carol's gaze.

"There have been three people I haven't been able to save. That cat was one of them. The first two were my best friends. David Grant. We were best friends in high school. Then we both went to the University of Michigan. He was an art major. He had an original Andy Warhol print in his apartment. And Patricia Alexander. We sang 'The House of the Rising Sun' together for the high school talent show. She went on to a school out of state. Each of them got married shortly after college. And I lost them."

"To marriage?" asks Carol.

"David was gay, but he was in denial. He left his wife and went to San Francisco. But he couldn't deal with his sexuality. He jumped off the Golden Gate Bridge. And Patricia. One night her husband found her. Hanged in the shower. A suicide, but I've never believed it. She wasn't the type. For years, I've had dreams about her being trapped under the stairs, trying to escape, and me not being able to save her. Sometimes in the dreams I am inside her body, trapped inside her body, and trapped under the stairs, trying to make noise, trying to call out, and not being able to . . ." she pauses. "I think Patricia was murdered by her husband.

"I'm the one who lost myself to marriage. But I saved myself. I fell in love with Laurence way too young. At eighteen. He was handsome, and very well read. He started beating me as soon we married, especially in the abdomen. It's a miracle Evan wasn't miscarried. Laurence broke my hands and my nose. He beat me until I was unrecognizable. Once Laurence made me a sandwich. I thought *how uncharacteristic*. Braunschweiger. He had hidden an enormous amount of LSD inside. For hours I saw only red and green. I stepped into the bathroom, looked in the mirror, and saw a reptile staring back. One morning, I packed up some things, whisked up Evan, and got out. I became unrecognizable on my terms. I changed my name from Elizabeth Hartshorn to Clare de Lanvallei, the name of an English ancestor of mine who was among the signers of the Magna Carta. Then after the second husband I finally married Rick. Then I had Joseph, *fourteen years* after having Evan. When I married Rick I just threw all my old names together. My legal name is Clare Christina Elizabeth Christine Hartshorn de Lanvallei McKay." My mother chuckles at her many names.

Carol feels the urge to cry, and roots nervously through her purse full of medications, pulls out her Visine drops, and drowns her eyes in saline.

"The hour approaches, Carol," my mother says.

"Let's *do it*," Carol says, dabbing at her Visine tears with a tissue.

CAT LADY

Carol waits on the porch, as my mother has instructed. She smokes an extra-long Marlboro Light. My mother wrestles Gummidge into a cat carrier at the back of the house, loads her into the silver station wagon, and pulls up.

When my father, a lanky man with a few wisps of black hair remaining on his mostly bare head, arrives home, no one else is there. He is coming from the grocery store that he manages. He places a carton of milk, a package of sliced turkey breast, and a bag of apples into the refrigerator and exhaustedly sits down at the kitchen table, amidst a sea of the last two weeks' newspapers. He begins idly reading one of them through his square-framed glasses. He remains there for thirty minutes before my mother and Carol burst through the door, cat carrier in hand.

"Roxy has an announcement to make!" my mother shouts.

"Who's Roxy?" my father asks.

"Roxy is a cat," she informs him.

"You got another cat?" he asks, his expression moving from puzzled to perturbed.

"Yes," my mother says, proudly.

"Jesus," he says.

"Would you like to meet her?" she asks.

"S'pose so," he answers. My mother opens the wire door and a calico scampers out. "That's Mrs. Gummidge!" my father exclaims.

"It was determined today, by the veterinarian, that the-cat-known-as-Mrs. Gummidge was not eight years of age, as previ-

ously imagined, but is, in fact, a sprightly one year old. It was also determined, at the veterinarian's, that the-cat-known-as-Mrs. Gummidge had a nasty sliver lodged in her side, causing her to cry and act generally like a curmudgeon. As this cat's age has been clarified, and her troubles assuaged, she wishes to put forth a new image, and asks, now, to be known only as *Roxy!*"

"Roxy is moving out of her *cell* and into my house!" Carol announces. She had once toyed out loud with the idea of adopting Mrs. Gummidge, remarking that two sad women might make one another happy. *The way two rawngs make a rah-at.* Now that Roxy has appeared, she seems to have revised her logic: a happy cat might cheer her up. She places Roxy in the passenger seat of her car and lights a cigarette. The two drive coolly away.

At 9:30 p.m., my father retreats to bed, as he always does. Soon thereafter, Cleopatra rises languorously from a living room nest and saunters up to join my father in the king-sized bed. As always, my mother remains in the kitchen, indefinitely, reading mystery novels and sipping flavored decaf, well into the deep sleep of Cleopatra and my father.

My mother sets her book aside and creeps out to revel in the new space of the pantry—the erstwhile home of a cat who suddenly switched lives and names. New discoveries have thrown the cat's former persona into a liminal zone between past reality and fiction. *Who lived here?* My mother asks herself. *Who was this "Mrs. Gummidge"?*

Mrs. Gummidge was a being with several names and a being

with no name. She was a Z-word that was hard to remember, with a face rendered gray by a limited and artful memory. My mother swoops up the bag of Whiskas, nearly empty now at the end of the day. She shakes it like a gigantic maraca, humming a syncopated version of "Cuddle Cats." Drawn by the sound of food—or perhaps by the Latin rhythm—Don Diego appears at her feet. My mother does not finish the song, but pours all the rhythm, the remaining morsels of Whiskas, into a Blue Willow bowl.

My mother turns, and begins to walk to bed. Mounting the stairs, she pauses, thinking that she hears the distant cry of a lost, hungry feline. She continues on her way. The stairs are loud and creaky and she barely hears the rustling of her spirit, down there again tonight, shifting beneath them.

THE ORPHAN BIRD

Last night over the phone, my mother informed me that she has a brain aneurysm and will undergo brain surgery in several months. Today I am at my office job.

I work at Bumble and Maw, a classical music publishing company whose main office is in London. I am positioned in The Rental Library, which is the bottom of the caste system. I refer to the staff in our department as "The Rentally Ill."

Patti is our boss. She is an opera singer. There is a hole under Patti's desk. Not just a hole in the flat green carpet but a hole in the floor itself, surrounded by a mound of concrete and debris. There is a pipe in the hole and it intermittently spews steam, which rises up above Patti's desk, through the dying leaves of a weeping fig. Patti is constantly announcing that she is "putting out fires," which generally means "dealing with the demands of cranky customers." This is a phrase drawn from standard office lexicon. But the steam over her desk looks like smoke and illustrates Patti's fire in a way, metaphorizing it as one that will never be put out.

Today Patti is slightly more centered than usual because she

has brought in one of her birds. Last week she brought in Newton, an African gray who knows various barnyard animal noises and occasionally sings the Queen of the Night aria. When Patti went upstairs for a meeting she left him in her office. For two hours he made the sound of a bomb being dropped, often punctuating the whistling descent with a sotto voce "boom!"

Occasionally he moved into "Pop Goes the Weasel."

Today Patti has brought in Cully, a forty-year-old parrot who was recently made an orphan when her owner, an elderly woman on the Upper East Side, passed away.

Patti sets Cully's little cage atop a file cabinet and says, "OK, everyone. I'm going for a meeting at the Met Opera Library. I should be back around four o'clock."

We all nod or grunt slightly. "I should be singing at the goddamned Met," she mutters as she exits.

For the next two hours I sit next to the phone and do not answer it. I have learned that there is, invariably, a clueless and panicked orchestra librarian on the other end trying to place a last-minute order. Each of the six thousand customers acts as though he or she is the only one.

I listen to the messages they leave me:

BEEP!

"Oh hi! This is Lisa from you-know-where," comes an apologetic and manic squeak. "I need to rent the Ravel *Bolero* ... again. Hoping to have the parts airmailed so they get here by

morning. Also *hoping* you can *waive* the two-hundred-and-fifty-dollar rush fee. Our orchestra is really struggling here. I'm sure you understand! Give me a call *as SOON as HUMANLY possible*! You have the number!"

BEEP!

"Heeellloooo. This. Is. William. Moore. That's *MOORE* . . . Not *more*, as in "greater quantity." Not *Moor* as in "Muslim," or *moor* as in "area of wasteland with poor drainage," but MOORE. That's Emmmm. Ohh. *Ohh*. Ar. *Ee*! As in Marianne Moore. The poet. If you don't know who that is, well, I should *advise* that you *learn*.

"Pressing on!

"I do not want to *rent* any *music*. But I am in need of some *information* that I'm hoping *you* can *provide*. It concerns the Ravel *Piano Concerto in G* and a certain eighth note, which is marked as a sharp, and which I believe should be marked as a *flat*!

I am hoping to compare notes with you—no pun intended—and see if we can't get to the bottom of this!"

BEEP!

"Hi Baby, it's Rhonda Finch. Santa Barbara Symphony. Listen Baby, I got a conductor breathin' down my neck here. I'm gonna need those advance string parts for Benjamin Britten's *Four Sea Interludes*. Pronto. Like *yesterday* morning. And I

THE ORPHAN BIRD

swear: if you charge me a *rush fee*, I'll break your goddamn neck! I'll stick a gun in your mouth! I would *never do that*! I *love* you, Baby. Call me!"

BEEP!

They are a culture of emergency. In response, I have transformed the phone lines at Bumble and Maw into a theater of deprivation. Before customers are forwarded to voicemail, they are placed on hold for several minutes as minimalist music plays.

If a customer insists that I must call him back by the end of the day, I will call him back the following one. If a customer leaves two desperate messages in a row, her name is moved to the *bottom* of the callback list. If she leaves a third, a thick and indelible black mark is drawn across her name and number. Some days I cross off so many names with that sharpie I get high off the fumes.

I am so enveloped in the world of the office I cannot imagine myself outside of it. I don't know who I would be if I were not here between 9 a.m. and 5 p.m. every weekday. I'm afraid I might have a breakdown if I found myself in my Brooklyn apartment at 11 a.m. on a Tuesday. Such a life resides in my mind at the very outskirts of possibility, the dragon at the edge of a flat world. And I cling to the perks of the job, which are, I imagine, the Wite-Out and paper clips I steal. For a year I've been telling friends that I'm going to quit. Each time I say it my eyes get a lit-

tle darker. I'm like Pirate Jenny, the washer woman invoked in the *Threepenny Opera*. She claims to be pirate royalty and plots vengeance against her customers as she scrubs the floors and waits for her ship to come in, that black freighter with the skull on its masthead. I imagine myself as her, speaking in a rough, showy cockney accent. *That's right! No more five days a week for THIS one. I'm gonna get ME a catering gig! Gonna make time for me work. Me art work. They'll see. Aw, they'll all seeee!*

One of my eyes is kept on the psychic ocean. I'm waiting to catch the first glimpse of that skull on that masthead, appearing on the misty horizon.

My other eye is kept on Google. I Google myself compulsively, hoping to find that I've been up to something, hoping to discover some encomium to me on a blog somewhere. Today, though, I Google *brain aneurysm*. I find a message board of survivors. They share experiences of the slow recovery process after surgery, and exchange little anecdotes about memory loss. One woman jovially recounts having temporarily forgotten who her husband was. Another responds with a story about how, one evening, she absent-mindedly made multiple trips to the grocery store and awoke the next morning to discover five cartons of milk in her refrigerator.

I begin to think of my grandmother, who sat in a chair for fifteen years without speaking or making eye contact. Her brain began to deteriorate when I was a child. I remember that my

mother had a talk with me one day. "Joseph," she said. "If anything like what has happened to your grandma ever happens to me I have an instruction for you. Are you listening?"

"Yes," I had said in my ten-year-old voice.

"If anything like that happens to me," she repeated, "if I am in a nursing home somewhere, I want *you . . . to bring me chocolate*. They may not allow it, but I want you to *smuggle it in*. Hershey's Kisses. OK? It's important that I tell you this now because when that time comes, I simply may not have the faculties to communicate it to you. But believe me, *I will want it*."

I am startled out of my recollections by the sound of a rattling cage. I look over and see Cully, the orphan bird. "Who's a dirty pooper?" she asks. Everyone in the office breaks out laughing. "You're a very dirty bird!" she says. She speaks in a New York accent with a smoker's voice. It dawns on me that this is the revenant voice of the bird's deceased owner. "Who's mommy's little pooper?" she asks, a dropping hitting the floor of the cage.

GHOST SEX

I am not saying I believe in ghosts at all, but I did have sex with one.

I never saw it but I did feel that cold feeling that you feel, supposedly, when a supernatural presence enters the room. I had only felt this cold feeling two other times in my life. Once when my friend Thain—who aspires to be a cult leader one day, by the way—took me to a séance in the Bronx and people were huddled into a side room at a botanica. One occult practitioner was waving some branches around and mumbling, trying to summon an otherworldly entity, and when I entered everyone looked at me and pointed and shouted "*Brujo! Brujo!*" announcing that I was a witch—even though I don't know the first thing about magic and what have you. But then, a few moments later: *whoosh,* a cold air overtook the room and the hairs on my forearm stood on end. Their spirit had apparently arrived.

The other time was when I'd been enlisted to portray the New York Dolls guitarist Johnny Thunders in the reading of a play. I began studying videos of him intently on YouTube, trying to imitate him and become him and then again, *whoosh*—my living room became alive with a chill and I was left to assume that

the spirit of Johnny Thunders was suddenly near. I am not sure I did a good job acting as Johnny in the presentation later that week, but I am inclined to suspect he was keeping tabs on me from the beyond.

Anyway, back to the story at hand. I was staying at an art colony that is famously haunted—if one believes in that sort of thing. Its lore involves fires, ailments, and the deaths of children whose graves are still scattered across the property. The place certainly gives off a gothic vibe. For instance, there's a Victorian mansion there where legend has it Truman Capote used to hold court from a strange velvet throne. Earlier that week I had been singing Schubert's "Litanei" in the music room of the mansion and a bat flew in and began circling me. I just kept singing: *and those who never smiled in the sun, but under the moon waited on thorns to see God, face to face in the pure light of heaven, all souls, rest in peace.* (In German, of course.) Round and round went the bat as the other artists snickered and cowered in the pews. I didn't even duck as it grazed my hair.

I sang in the mansion but I wasn't sleeping there. I had been put up in one of the satellite buildings, a partly subterranean apartment in a house. Dank but charming, it had linoleum floors and faced a distant wall of trees—it felt like the home of some old relative I'd visited in my childhood. A frazzled playwright warned me that he had once stayed in that room and a ghost threw a teacup at his head. But this man was terrified by the entire premises and would drive in his SUV from building to build-

ing—distances of twenty feet or so—for fear of hostile outdoor specters, and insisted that other residents accompany him to and from his car. He also had contended with spirits at other art colonies and in the town where he lived. So I assumed that he was just a universal ghost-magnet, irresistible to the unseen. And I didn't anticipate that I myself would have to dodge flying china in my cozy little abode.

Aside from hauntings, this art colony is known for being host to much cavorting; various twentieth-century masters of literary and musical form reputedly engaged in orgiastic escapades here. So when I received the acceptance letter, my friend Sheila implored me, in her Southern accent, with all the drama of a Tennessee Williams character, "Joe, *please* tell me you'll have an affair there! God, promise me you'll have one! Don't you understand? It will make your relationship *stronger!*" But I was determined to be on my best behavior because, as Sheila indicated, I had recently entered into a decidedly monogamous arrangement. In fact, I had just returned from a romantic trip to Italy, and I set up various postcards of Bellini, Masaccio, and Fra Angelico around my bed to remind me, at night, of my trip and my love.

But it was hard to go to sleep in my apartment. First off, it was very dark outside and I had to creep around a stone path in the black buzzing woods, to the back of the house, which spooked me a bit. Second, my apartment was attached to an old tool shed that you could get to from a passageway connected to the living

room, through a filthy corridor that looked like the perfect terror-chamber for a serial killer to keep his victims chained up in. Third, every time I was on the verge of sleep I would see a white flash of light that would snap me back to the waking world and then there'd be a series of frantic footsteps emanating from the ceiling directly above my head.

I knew there was an eighty-something who once wrote for the macabre soap opera *Dark Shadows* somewhere in the building, working on a novel or something, and I figured he must have taken to doing midnight dashes across his room, perhaps as a form of physical fitness. Or maybe he was still asleep, and was simply being swept into spasms of somnambulant dancing. This explanation still wouldn't account for the white flashes, but I was willing to accept those as figments of my imagination.

One morning, after a particularly restless night, I inquired as to who was in the apartment above me. The lady behind the desk in the office replied, "Oh, no one's been up there for years. That's just used for storage. The only other active rooms are on the other side of the house."

This piece of information, which clearly supported the existence of the paranormal, both troubled and delighted me. I was unsure of what to do. Should I call my love, a self-avowed "materialist" who claims not to believe in anything that can't be observed? Yes, perhaps some skepticism would be of comfort. I picked up the phone, but instead found myself dialing my witch friend, Thain, an expert on supernatural codes of behavior and

spectral etiquette. He had just awoken at 4 p.m. "So you want to banish a spirit?" he asked in his low, slow, South African drawl.

"Well I can't banish this ghost, because *it* lives there and *I* don't," I explained worriedly. "But is there some way I could make peace with it, so it would stop stomping around and disturbing my sleep?"

"OK, calm down. I hear what you're saying. I do *hear* what you're *say*ing," he repeated, like a drunk therapist. "I'm hearing that you want to *commune* with a spirit."

"Yes, commune," I repeated. "I guess that would be it . . . A friendly gesture. Is that possible?"

"It is possible," said Thain. "It is . . . possible. It's possible. What I can do is I can—what I can do . . . What I can do is . . . is I can give you an *incantation*. OK? An incantation, and a few instructions. Listen carefully. You're going to need a hand-dipped white candle and some whiskey."

"Scotch or bourb—"

"Bourbon," he said decisively, as though I were offering to hand him a glass of it right then.

That afternoon I made one trip to a new age-y store in town, and another over to the liquor store. I had no idea how a ghost could drink whiskey, but I hadn't made a fuss on the phone and chose not to overthink it now. After dinner that night, and the customary coffee hour that followed, I ventured back to my dwelling, and prepared everything just as Thain had instructed me.

GHOST SEX

I was to set out the whiskey on its own surface in a conspicuous location, as one would when leaving a glass of milk out for Santa Claus. So I dragged my nightstand to the center of the room and poured a generous amount of bourbon into a clean tumbler. Next to this, I lit the candle. I had scrawled the words to the incantation with purple Crayola marker on a sheet of paper torn from my giant desk pad.

I studied the words and tried to memorize them. Some phrases were in English, some polite way of expressing, "Spirit, let's get real, wouldn't you fancy popping in for a few glugs of bourbon?" And other phrases were in an unrecognizable language—I'd transcribed Thain's words phonetically, but had no clue what they meant.

Sitting cross-legged on the floor, I began repeating the invocation, the invitation. At first nothing happened. A distant creaking startled me. I arose for a moment, poured myself a glass of whiskey, took a sip, and set it aside. I closed my eyes again, regained my composure, and muttered the words again. Then I waited and repeated them again. I don't remember how many times I repeated these words but at a certain point: *whoosh.*

I was enveloped by a coldness, a coldness that did not, however, make me huddle or shiver. My arms lifted, as though they were preparing to wade in a pool. Then I was overtaken by a pleasant numbness. I felt that I no longer had control of my body, but I could feel it tingling everywhere. My arms moved very slowly up and down, and into different positions, twisting

gently, as though guided by another presence. My spine shifted. It was like an erotic physical therapy session. And though Angela Lansbury's workout routine for the elderly, which Sheila had often described to me, sounded more aerobically vigorous, I suspect now that *this* strange yoga amounted to a more blissful experience.

My ghost was a body worker.

I was not sexually aroused in the traditional male sense, but every part of my body was erotically alive, the way I imagine people feel on certain drugs. If someone had been watching I guess they would have seen me sitting there in the candlelight, raising my arms again and again, like a lost raver, for perhaps an hour or more.

At some point I felt like I was being carried to my bed. For the first time in that room, I slept quite peacefully.

When I awoke that next morning, full of life, I found a puddle of white wax and two glasses of whiskey, both seemingly untouched. The footsteps ceased for the remainder of my stay, as did the flashes of light. We engaged in no further sessions. Although it was brief, and possibly imagined, I supposed that now I had an affair to tell Sheila about. But I would wait to tell my partner, who I knew would be upset that I believed in ghosts.

ANXIETY DREAMS
AT THE AMATO

I've had all the classic quotidian nightmares: that I'm out in public, going about my business, but—oh no! I'm not wearing pants! Or that I must take an exam on a subject I know nothing about, apparently after registering for a course in some rare moment of virtue and then forgetting to attend it for an entire semester. Most often, though, I dream that I am required to step onto stage in a play at the last minute, even though my lines are a mystery to me and I never rehearsed.

By the time I was twenty-two years old, many of my anxiety dreams had come true. I had been pants-less on the street—though this occurred, more or less, of my own volition (as after yoga one afternoon I decided that the line for the changing room was unreasonably long so I simply decided to disrobe and re-robe on the sidewalk.) And my senior year of college I'd mistakenly registered for only one section of a two-section music theory class, so the exam was, indeed, brimming with surprises. However, I had thankfully never been slated to perform a role on stage, unbeknownst to me.

Upon finishing college I promptly moved to New York. By day, I hawked audio guides at the Guggenheim, working as a living bulletin of sorts, repeating, "We have audio guides available at the box office" to every visitor in line. And in the evenings, I used my voice in a different way: I sang at a sixty-year-old opera company in the East Village, known as "the smallest grand opera in the world." It sat next to the Bowery Mission, a men's shelter and soup kitchen, and two doors down from the legendary punk club CBGB. There was a time when denizens from all three places routinely stood outside for fresh air, or a cigarette, and sometimes one could not tell who belonged where.

Certain critics regarded the Amato Opera as an amateur house, pointing out that *amato* and *amateur* even shared the same Latin root. But to me, "amateur" was not a precise description. The company was a really heterogeneous mixture—a lively, familial group of up-and-comings, would-have-beens, professionals who might be confined to small roles at the Met but who could tackle leads at the Amato, and a few characters who I imagine might never have been permitted—by casting directors and perhaps by law—to sing anywhere else.

The man at the helm, Tony Amato, the tiny, fiery, Italian octogenarian who founded the opera company fifty-some years before, famously believed in giving everyone a chance.

For many of us singers, the Amato felt like home. For others, it *was* home. Stepping through a curtain in the dressing room one evening, I discovered that I had entered the makeshift apart-

ment of the lead baritone, who had lost his day job months be-
fore, and of his girlfriend, a mezzo who had emigrated from
Eastern Europe to get her foot in the door of the American clas-
sical music scene. Despite my initial intrusion, the pair soon be-
gan inviting me to stay on after rehearsals and hang out. We
would pass around a bottle of bourbon, all three seated in a row
in the dark opera house, or play poker around a table onstage,
among the set of Café Momus from *La Boheme*. In the daytime,
the couple had only a little curtained nook to themselves, but at
night, they could freely roam any of the four floors of the opera
house as if it all belonged to them.

Tony Amato was a generous man. He took care of his singers.
As I observed in my first few months of singing there, while I
was mainly doing chorus parts, Tony was so generous that rather
than giving each role in an opera to one person, he would give it
to, oh, eight or nine people. This meant that you would only get
one actual rehearsal onstage before your performance, and the
rehearsal might or might not be with the same people you'd sing
with in the actual show. So you might have to perform a sword
fight or a love scene—or execute an intricate slapstick routine—
with a perfect stranger, in front of a hundred more strangers
who were sitting quietly in the darkness and had paid to watch.
DVDs of past performances were made available as rehearsal
aids, and one could look forward to viewing those an infinite
number of times, in preparation. The process struck me as
vaguely equivalent to being asked to perform surgery on a live

ANXIETY DREAMS AT THE AMATO

body, after only playing a few quick rounds of the board game *Operation*, or perhaps competing in the Indy 500 after squandering all one's quarters to sit in a simulated racecar at the video arcade.

"Do-si-do, goddamn it!" Tony would bellow at the chorus as we struggled to properly execute the straightforward arm-in-arm folk dance, one of the major choreographies of the house. In certain party scenes, or sequences that involved commotion on the street, Tony would raise his fists and shout, "Chaos! Chaos!" to the chorus. Because we were always struggling through a true state of chaos, to one degree or another, it was hard to make chaos *read* in a dramatic sense.

I often wondered if Tony relished a certain balance of order and disorder. I can't help but think that to stay in control, he liked keeping everyone else just a little bit out of control. I sensed that he didn't want anyone walking around like they owned the place, since he wanted to walk around like he owned the place, and he did own it. He was always the only one who fully knew what was going on. As director of stage, music, and casting, chief conductor, universal understudy, and head meatball chef, he was omnipresent, depended on at every turn.

In the midst of short scene changes during a performance Tony would set aside his conducting baton to dart behind the curtain as though there were a fire to be extinguished—to see to it that a *Birth of Venus* statue or some two-dimensional flower pots were being properly screwed into the floor, which they

ANXIETY DREAMS AT THE AMATO

never were, as any startled crew member was apt to drop his drill at the sight of the crazed maestro. In these moments, Tony was something like an anxious backseat driver whose relentless stream of cautionary remarks causes you to crash the car.

Sometimes Tony would even direct during a performance. Continuing to lead the chamber ensemble with his conductor's baton, he would impart various instructions to a singer onstage.

"Psssst!" he would say in a stage whisper that the entire audience could hear, "Psssssst! The key! Don't forget to take the key from the statue . . . no not yet!"

We singers developed strategies for dealing with the challenges of the environment. If you forget your words during a performance for example, try singing nonsense.

One of my first roles was Ramfis in *Aida*, and in one part I was supposed to be reading a grave list of charges against Radames, who was being tried for treason and faced execution. The Italian words slipped my mind, so I simply began listing the names of various pastas—fettuccine, rigatoni, et cetera—and the audience, comprised mainly of Americans, did not seem to notice.

Such a technique will unfortunately prove less effective if the opera is in English. Once a retired Wagnerian playing the title role in *The Merry Widow* forgot her lines in the middle of a party scene where she was making a toast. Unlike some opera singers, this one had excellent diction—every word was crystal clear—so when she began singing complete gibberish with her cocktail

glass raised in the air, one wondered if she might be suffering a stroke, or if we might all have passed into another world.

Because we never enjoyed the privilege of a purely musical rehearsal at the Amato, we were expected to learn all the music on our own and hopefully go over it with a coach. My coach was Sheila, one of the resident pianists at the house, a fifty-something Southern transplant with dramatic flair, who refused to take payment from me after one of my checks bounced, and who ended up moving into my living room for a spell some years later.

During our coaching sessions, Sheila and I would luxuriate in her Greenpoint living room, downing pots of coffee, bottles of wine, and various packaged desserts as we discussed our love lives and urban escapades, with occasional interludes of working on music. Sometimes we even swiped a pack of Sheila's son's cigarettes and made ourselves sick on nicotine.

"Have another beer, Joe, I beg you. Have a cigarette, for God's sake. You have a low voice. You're a *bass-baritone*. Smoking and drinking will help you!" Sheila assured me. She was a singer herself, and in addition to flying through the score on piano she would sing every other part in the opera aside from mine, adjusting her voice to fit the different characters.

"Now, when I sing the male parts, I am aware that I sound like a Munchkin from Munchkin City. I just want you to know that I do know that," she remarked one day.

When I would arrive at my Amato rehearsal it was always

something of a shock to me that there were suddenly other entities singing onstage—independent agents who were not merely different shades of Sheila.

The music was one problem, but learning the intricate staging was another challenge entirely. In order to map out our characters' movements, we were encouraged not only to study those DVDs, but to attend other peoples' rehearsals, intently watch the singers on stage, listen to what Tony told them, and scratch notes into our scores so that we would be ready, come our day of rehearsal—or day of reckoning, as the case may have been.

If you didn't know your music or staging, Tony Amato was liable to scream at you in front of everyone, and might even throw you out. Sometimes Tony would yell at you for no apparent reason at all. And he designated whipping boys. For a certain period, for instance, he would exclaim "Damn it, Daniel!" every time anything went wrong, whether or not the mishap was the fault of, or even remotely related to Daniel, a lanky lawyer who sang at the Amato in his off-hours.

The company as a whole did not resent Tony's outbursts. He was beloved even in his rages. While the good-humored Daniel snickered whenever his name was shouted, most of us preferred to avoid being the target of Tony's hot temper. When he assigned me a role, accompanied by a warning, I knew I had better watch out. I had already done a couple parts when he decided I was ready for The Bonze, a mean uncle in *Madama Butterfly*

who storms across the stage to curse Cio-Cio-San's marriage to an American. Tony took me aside, pointing his finger at me. "It's small," he said. "But it's tricky. Very tricky."

Despite Tony's admonition, I procrastinated working on The Bonze for as long as possible. I'd been putting in long hours at the Guggenheim, and hadn't had a chance. Besides, it was only one page and I couldn't fathom not being able to learn it in time.

"You ready for Bonzo?" asked the lead baritone as we sat up late one night, two weeks before my performance date. "Tiny, but it's a killer."

It was time to call in the big guns: I needed to see Sheila.

"Oh Joe, that part is about ten beats long and you could sing it in your sleep tomorrow," she declared. "I'm sorry, but anyone who claims otherwise is a drama queen." But when she walked me through the scene on a Wednesday night, my part felt loud, taxing and rhythmically complicated. As we said goodbye, even Sheila changed her tune. "Well, I do think we could stand to run through it just a *few* more times."

The following Sunday afternoon, as a prelude to Work Session Number Two, Sheila and I decided to indulge ourselves with a brunch at our favorite local diner, Donut Coffee. "Doco" we sometimes called it, envisioning a gentrified future in which all names had been replaced by a cutesy abbreviation. For some reason, I decided to order practically everything on the menu.

Sheila certainly did not attempt to stop me, as she has never been one to discourage fits of excess. I ordered a Farmer's omelet with cheddar, home fries, toast, bacon, a stack of pancakes, and a bagel with cream cheese on the side.

In a kind of gluttonous Zen, I had achieved a state of immobility, and was still nibbling here and there, when I received a call from the Amato.

Where are you? asked a voice on the other end. It was Irene, Tony's niece and the company manager. *The first act already started. Are you on your way?*

I had studied the elaborate charts sent to me, indicating which days I would and would not be on. But occasionally at the Amato, the schedule would change, and certain key parties would not be notified. And on this particular afternoon it seemed I had been scheduled to play Uncle Bonzo. So while I should have been making myself up, singing scales, examining my music one last time, and putting my costume on, I was instead gorging myself in Bushwick.

"Just go, Joe. I'll pay!" Sheila exclaimed. So I tore out of Donut Coffee, bloated, a human festival of cramps. "Make. It. Up," mouthed Sheila through the diner window—as I started off down the street to catch the elevated J train I heard rattling towards my stop. Was she talking about the words or the notes or both? The sound of the train got louder and I tried to pick up my pace. I managed to make it to the back entrance of the station. I bounded up the first set of stairs as the train arrived, only

to realize, with horror, that I did not have my MetroCard. A man had just swiped his and was about push through the high wheel.

"I have an emergency!" I panted, shoving the front of my body against the back of his, so that I could go through with him.

"Oh OK," he said, making no fuss, either out of an uncommon spirit of benevolence or the impression that I might be dangerous.

I ran up ahead, hurled myself through the closing doors, then stuck my arm in between them so that they would open again for the stranger, my kind assaultee.

As the train lurched over the Williamsburg Bridge, I was seized by nausea. "Cio-Cio-San . . . *Abbominazione* . . ." I mumbled Uncle Bonzo's lines quietly, massaged my stomach, and pressed my fingers into my temples. I got off the train and ran up the Bowery, darting in front of traffic on Houston, and fielding hordes of people who moved slowly, and in clusters, evidently out for enjoyment on a Sunday afternoon.

I ripped open the Amato's door and galloped up its rickety stairs. "Shhh," went an elder chorister, a certified MENSA member who was currently berobed and powdered, dressed in scrappy Orientalist kitsch as a Japanese servant. He pointed his finger downwards to indicate that the show was going on below. Irene sighed dramatically once I reached the dressing room area. "Just do the basics," she said: I had five minutes to put on my robe and paint a little goatee on my chin with eyeliner.

In the Amato production, Uncle Bonzo begins singing in the

house, from the audience. Then he storms up the aisle and ascends to the stage to ridicule his niece at her wedding. I ran quietly down the stairs and crept through the door to the theater and tiptoed solemnly to the back of the house, by the drinking fountain. I leaned over and took a small sip of water. "Cio-Cio-San, Cio-Cio-San," I repeated in silence. I began trying to calm myself down, and to breathe deeply, as one is supposed to when singing opera. As a contingency plan, I began reviewing the names of Italian cuisine, but the thought of food made me increasingly ill. And as the heavenly chorus that preceded my entrance wafted through the room, the jostled diner feast inside me could remain inside no longer. I staggered back to the drinking fountain just in time to vomit profusely into it. One, two, three heaves, and out it all came. Remarkably, as though it were a single action, I was able to go from puking to singing, lifting my head to enter with my lines at the correct moment.

"Cio-Cio-San! *Abbominazione!*" I sang. I proceeded to lumber angrily toward the stage, as Tony conducted spiritedly from the pit, theatrically wiping his brow as I came up the stairs, as if to indicate, *Good thing I didn't have to take over your role today.* I delivered all the nasty, tricky business I was supposed to. I only had to make up one or two words.

I can't remember if I sneaked back later and cleaned up the drinking fountain, or disavowed any knowledge of the mess I'd made. In any case, no one ever commented on the incident.

I am still visited by anxiety dreams. I am always about to go

ANXIETY DREAMS AT THE AMATO

on, despite being ill-prepared. Sometimes I have some final opportunity to glance at a script a few minutes before, but I always blow it by getting distracted and then must brave the stage, bewildered as an amnesiac, but hoping against all odds to retrieve my lines from somewhere in the collective unconscious.

In contrast to the incident at the Amato, the anxiety dreams are actually full of luxuries: I am always already at the venue, my brunch is never disrupted, and I don't have to book down the street on a full stomach.

On the other hand, if there is something uniquely frightening about the dreams, it is that the world around me is unknown and startlingly anonymous. I have the sense that I am on trial, but whether for treason or fettuccine, I am unaware of the consequences and don't know who my judges are. I risk failing in an arena where there are no Tonys or Sheilas, and I fear it's a place where chaos is never encouraged.

IL PIRATA
DELL'OPERA

Opera Pirate

RECITATIVO

Voice

Allegretto *mf*

Il pi- -ra- ta dell' o-pe-ra è un ven-de co-pie d'o-

The opera pirate is a man who sells pirated

Piano

mf

Voice

pe - re pi - ra - ta. Mi die-de un la-vo-ro, co-pia-vo i C D. Co-

opera recordings. I went to work for him, copying CDs.

Pno

Voice: -pia-vo, co-pia-vo, tu-tto il gior - no, suo - ni ru - ba - ti, men-tre

All day, duplicating smuggled sounds, while

Voice: par - la col gat - to, con-trol-la la sua trup-pa. Li co-pia-vo a più

he chats with his cat and checks on his crew. I copy them as

ARIA

Voice: non pos - so. Sul-la na - ve del pi-

fast as I can. On the ship of the

-ra - - - ta, as-col-ta-va - mo gran - di can-

pirate, we listen to scratchy recordings of

-tan - - ti. E io li co-pia-vo. Can- tan - - ti o-ra

great singers. And I copy them. Singers who are

vec - - - - - chi, vec-chi o de-

now old, old or

-fun - - - - ti... Nei lo - ro ca - val li di bat-

dead... In their greatest

-ta - glia. Di so - - - - li - - to dram-

moments. Often dramatic

-ma - ti - che sce-ne di mor - - te:

representation of death.

76

ma - ti da un grup - po di cri-mi -na - li di raz - za. In

Captured by some criminal connoisseur. We

al - to ma - re con - fron-ta-va - mo ot - ta - - ve es -

Compare high Cs on the high

tre - - - - - - - me, al ser -

seas, in the

-vi - - - - - - - zio di chi è in

Service of people who are

cer - - - - - - - ca d'is - tan - - ti per -

on a quest for

- du - - ti che mai si pos - so -

lost instants, which can

rit.

-no vi - ve - re per la pri-ma vol - ta... Ma so - lo vi-

never be lived for the first time... But which can

-ve - re an - co - - ra.

be lived again.

Rall.

THE GERRY PARTY

While she is not an expert in antiquity, my boss Gerry Visco, longtime administrator of Columbia University's Department of Classics, behaves like a Roman emperor. Having been out all night, Gerry typically arrives at her nine-to-five position at 2 p.m. with curlers in her hair. "Where's my coffee?" is the closest she comes to a greeting.

Gerry does not "tone it down" for the office. To the contrary, she may be seen wearing a mangy aqua-blue faux-fur coat, a skintight iridescent disco suit that billows out at the wrists and ankles, an apricot straitjacket with ravaged shell pink fishnets, or perhaps even a bright-yellow bird costume—jazzed up with a matching tutu and four-inch heels. If Coco Chanel's dictum was *before you leave the house, take one thing off,* Gerry's is *on your way out, remember to pick a few more fetching knickknacks off the floor and attach them to yourself.*

You always know Gerry's coming because you can hear her footsteps. You can also hear the chain of smiley faces and bouquet of rape whistles clinking against the rhinestone-studded emblem around her neck. This used to read "BLACK GIRLS ROCK" until "ROCK" fell off one day. Now it simply reads "BLACK

GIRLS" (Gerry is white). Other days we employees simply hear the music, as Gerry has planted a wireless speaker in one of her four or five purses. This is connected to her iPhone and often blasts "Everyday I'm Hustlin'," "Sex Bomb," or "She's a Bad Mama Jama" on loop. *And what other items are held within the five purses?* you may ask. A "spy watch" with a hidden camera (which she ordered online), makeup and accessories, crinkled utility bills and possible eviction notices that Gerry has been working up the nerve to open one day, and stacks of pages from an unfinished memoir. Gerry also travels to work, and everywhere, carrying several cameras around her neck, as though she might grow as many arms as Kali Ma and be able to wield them all at once. And at night, she tries to do just that: after office hours and after dark, when Gerry bursts through the door of any nightspot, a flurry of camera flashes ignite the room. *What celebrity just entered?* wonders everyone in the club. They turn their heads to find Gerry, who captures shots of their stunned faces. Pioneering a new genre of photography-as-performance, she is the documenter who does *not* want to disappear. Quite the opposite: even from behind the camera, she manages to upstage her subjects.

I first met her when she interviewed me about my work on a radio show she was hosting at the time. It was called *Arts and Answers*. As far as I can remember, the interview consisted of some amusing non sequiturs and a few questions, such as "So do you like cats or what?" repeated several times.

THE GERRY PARTY

She also asked me to sing something, so I rattled off a few bars of Screamin' Jay Hawkins's classic "I Put a Spell on You," which I first performed for a middle school talent show, though my voice, now low and operatic, has grown into the song over the past fifteen years. As I finished, Gerry insisted that I must audition for one of those singing competitions, namely *American Idol* or *The Voice*. "Look motherfucker, are you dense or what?" she prodded. "You wanna be an underground artist or a national star? Look, you! You can be underground when you're dead."

"I can't sing those contemporary pop songs," I'd said. I proceeded to explain to this woman, roughly thirty years my senior, that I have always felt the victim of a strange, insidious sort of ageism. I've always felt I was *of* an earlier time. Not a specific era, mind you—any period between the Renaissance and the eighties sounds more-or-less homey to me. I can sing baroque laments, innuendo-laden blues from the 1920s, torchy ballads, classic rock anthems and even proto-goth dirges, but I'm afraid I can't convincingly sing one hit I hear playing on the radio at the bodega across the street from my apartment. I can sing songs that have, in one way or another, passed into a cultural afterlife and taken on the designation *classic*.

"Oh. Well you're probably not very good at making money, huh?" she commented with a chortle. I neither confirmed nor denied her supposition, but she was right.

On my way out of the studio, Gerry handed me a flier with a picture of a very striking, oversexed young bombshell with plat-

inum Marilyn Monroe–type hair wearing a skintight gold lame bodysuit, standing seductively off-kilter in a delirious red velvet interior. "That's me back in the seventies," she'd said. "Come to this exhibition if you can. It's all old pictures of me." Intrigued, I saved the date. In the meantime, my interview with Gerry aired. It sounded like she had applied a William Burroughs–esque editing technique to my answers, cutting them up and splicing them together, willy-nilly. Feeling un-precious, I admired the effect.

Several days later I ventured to the Lower East Side gallery to check out the show. Sure enough, the room contained portrait after portrait of the young Gerry. In many images, she was done up à la Marilyn, posing provocatively in some lush hallway, or biting her nails on a sofa, or vamping in a bathroom. She looked beautiful, if downhearted. In other photos she was dressed as a chic biker, with cropped hair, hanging around with other leather-clad urban creatures of the gay 1970s who looked like they might belong to the milieu documented by Nan Goldin. Indeed, Gerry once took part in a *ménage a quatre* with Nan, I later learned.

There was no gallery attendant present and I was the only visitor. But in the back corner of the gallery, next to the final photograph, sat the contemporary Gerry, having taken up residence amidst a stockpile of Chablis.

"Well I look a little different now, huh?" she remarked with a chuckle, gesturing toward the image next to her, taken thirty years before, where she's standing in front of a window with a

clear plastic shirt made of high-end bubble wrap. You could see her nipples. I looked at the photograph and back at her. Well, her approach to cosmetics had always operated according to a *more is more* principle.

"Have some Chablis," she said. "It's cleansing." We began talking.

The rest of the evening is a blur in my mind, but we had solidified our friendship sometime before the third glass of wine was poured. Soon we were hanging out at all-night Mexican diners, low-lit dive bars, and sometimes at the overpriced Bowery Hotel, where one night she decided we would drink margaritas. "It's a truth serum," she pronounced.

Indeed, it was there, in the faux–Old World interior of the "BoHo," that Gerry revealed much about her life. She told me that she had earned three writing degrees from Columbia University, all while working full-time. Currently she was penning short articles about art and nightlife for several publications, she told me, and had taken thousands of photographs this year. Before her academic and journalistic pursuits, she had worked as a hooker for eight years, in the seventies. At that time, she had supported her gay roommate, the photographer who took all those photos of her in their youth—she was once in love with him, but now resented him.

Gerry and I sat by the fire as she told me about her life in those days. As she joked about how she used to answer the phone in the middle of giving a blowjob, I couldn't help feeling that I had

heard the story before. Then I remembered: I had come across an article about six months before, a vivid and snappy personal essay by a former prostitute who bragged about her extravagant purchases at Bloomingdale's and adventures at Studio 54, while recalling the danger and grit that characterized life in New York City in the 1970s. The essay had been published anonymously in a free, alternative newspaper. I had read it while riding the J train one afternoon, and had been very struck by it. I'd even saved the paper and had wondered sometimes who the mysterious *anonymous* might truly be, eventually deciding she was probably a famous movie actress or prominent novelist who didn't want to damage her career by confessing to a history of sex work. But it was Gerry who wrote the piece, I now realized. I didn't bring it up in the moment, though. I simply kept listening.

In the next decade Gerry had fallen for a bisexual hustler named Jimmy, who later died from hep C. More recently, she spent some years shacked up with an impotent celebrity biographer, a fabulist in the first degree, who spun outlandish stories about the Kennedys and the tête-à-têtes he had with them. (He even invented people, such as "Officer Duffy," the source for his claim that RFK once strayed from a picnic in Virginia to ride around on a motorcycle and have public sex.) After convincing Gerry to give up her rent-controlled apartment on Central Park West to move in with him, the biographer ended up cheating on her and pushing her out. I got the impression that Gerry con-

sidered her photography and writing not only a reclamation of her creative pursuits, but a specific revenge against the men from her past. "I'm takin' the pictures now," she remarked at one point, with a hint of menace. "Another margarita," she commanded the bartender. "And this time, why not put some tequila in it?"

That same night in the Bowery Hotel Gerry offered me a job. She was telling me she'd gotten her "mojo back" after decades of long-term relationships had stifled her ambition and subdued her self-expression. She had just sworn off men, vowed to start acting again, and announced that she would soon pen an autobiography, when the subjects of money and work came up.

"I've got to write my memoir, and I'll do whatever it takes to get it done. I'm doing *my* thing now," Gerry declared. "Of course my day job is a drag, but what can you do?" She peered at me through the bejeweled white cat-eye glasses that were her trademark that year. "Speaking of which, you never seem to be working, I've noticed," she commented. "And I find the whole thing very suspicious. How do you make money, anyway?" she asked. "You give special massages, or what?"

"I don't do that, and I don't make money at the moment," I laughed. Perhaps compelled by the margarita, I went on: "I've been buying food on a credit card for three months now."

"Are you kidding?" Gerry asked with a distressed sigh. "That's no good at all." She hesitated, the warm orange light of the electric fireplace log flickering mechanically across her face.

"Do you want a job at my office?" I looked down and rubbed the bottom of my shoe across the Persian rug, a little this way, a little that way, as though stirring up a small cloud of dust at the edge of a baseball diamond. The truth was I didn't *want* any job, despite the fact that the gas in my apartment had already been shut off. I clearly was in no position to refuse her offer. I lifted my head.

"OK," I said. And with those two syllables, a Faustian bargain was made. I would soon be introduced to another Gerry, the Gerry of the office: patroness, captor, boss.

Gerry expects compliments immediately upon her arrival at the office. "Did you notice the hair or didn't you?" she asks her employees, clicking on an iTunes playlist of "booty mash-ups." "Stairway to Heaven" vs. "Oops! . . . I Did It Again" commences. "Maybe you ingrates would be happier without a job!"

Gerry has staffed her office with one female secretary and a bevy of twenty-something boys she refers to as "twinks," a term which in the homosexual world is shorthand for slender, smooth, naïf boys who, due to their bright glow of youth, are easily desired, and who, because of their simple, dizzy minds, are comfortably discarded. Gerry says having them around "gets my blood flowing." (The emperor Tiberius, by the way, trained small boys to swim through his legs and tease and nibble at his genitals. He referred to them as "tiddlers.") Gerry has broadened the gay definition of "twink" to include young arty

THE GERRY PARTY

straight men and, hypothetically, even women. I am one of the so-called twinks. Gerry has hired us for our company. Some days we gab with her about Antonioni, Kafka, and underappreciated French electro-pop. Other days she is altruistically preoccupied with giving us advice on our various endeavors. Her "encouragement," all expressed in the form of threats, makes her something of a dominatrix life coach.

And yet many of our days are simply spent at Gerry's mercy, in complete service to her whims. We pour her gin and tonics—she has installed a full wet bar atop a file cabinet, and has found that gin "wakes me up." When she needs a refill, she shakes the ice in her lipstick-smeared plastic tumbler, like a beggar shaking a can of grimy nickels at a well-to-do passerby. We prepare her cappuccinos. We pick up whatever objects she may have hurled to the floor in a fit of anger. She addresses us as "stupid," "dum dum," "idiot," "pig," and most recently, as "baby buns," a mock-term-of-endearment she proudly invented while deriding a cab driver. We exist as both spectators and sounding boards. "Look at this," the empress beckons. At the utterance of this familiar phrase, we automatically rise from our seats to wade through towers of magazines, crates of liquor, plastic swords, and fallen Beanie Babies, to the other side of Gerry's vast and cluttered desk in order to watch a four-minute video she made of herself dancing at home the night before. "Doesn't my hair look fabulous in this one?" she asks, smiling like a child awaiting her parents' approval as she presents them with yet an-

other completed diptych of scribbles. *Fabulous,* we are obliged to repeat. We twinks are also required to view endless series of Gerry's self-portraits, and pictures of her that have been tagged on her multiple Facebook accounts, by her or one of her 10,000+ friends. The photos often depict Gerry in the men's bathroom at one nightclub or another, standing on a toilet seat with one leg, and screaming like one of Francis Bacon's popes. Sometimes we are even treated to an erotic tableau. One found our mistress in front of a row of urinals, diddling tongues with a couple of restroom users she had recruited. Another showed Gerry making out with a very sloshed Macaulay Culkin in a dive bar. The next day a message appeared in Gerry's Flickr account. *It's Macaulay. Please take the pictures down.*

A parade of visitors streams through the office. Among them are Gerry's interview subjects, club kids, and no fewer than three people afflicted with paranoid schizophrenia, who have each chosen Gerry as their sole confidante, even though Gerry considers them merely casual acquaintances. "They put a chip in my brain," one griped quietly the other day, standing in the doorway to Gerry's office.

"They who?" asked Gerry with a tone of utter indifference, as she continued clicking through some of the fifty or so tabs that were open on her mammoth MacBook.

"Who d'ya *think*? C'mon Gerry, you're not stupid," replied the visitor exasperatedly. "The *Cambodian government.*"

"Oh," said Gerry. "Well, do you want a coffee? Hey," she bel-

lowed, "can one of you pigs who works for me get my friend here a cappuccino?"

These days, all visitors must announce themselves, because Gerry can't see them. She decided it was more important to sport long feathered false eyelashes than bother with the cat-eyed prescription glasses that were once her trademark, so Gerry can no longer see more than about four feet in front of her. "Is that you?" she often asks as a figure stands in her doorway. Invariably the answer is "yes." Occasionally, she rummages through a purse or two, pulls out a stray lens, and holds it up to her eye like a monocle in order to observe her guests more clearly. More often, she simply presides over the blur.

"I need my Instagram," she whimpers daily, as if *her Instagram* were a pedicure, or some other sybaritic little treatment. "My fans are waiting!" I, or another administrative assistant must follow her into the seminar room, where she will lie across the conference table amongst a few stuffed animals, or pose cheerfully next to some obscenities she has scrawled on the chalkboard. And I, or he, will shoot her portrait, so that she can release it into the world. But first, the critique. *The lighting's better over there, by the bust of Socrates! Duh! My stomach looks big in this one—ugh! Why didn't you say something funny to relax me? You're getting a little better at photography, but you need more practice!*

You may be under the impression that my colleagues and I do *no* work for the department, but that's not quite so. On occasion,

a gaunt professor of elegiac poetry ambles in, squints fearfully at the mammoth Xerox machine and then asks in a small woebegone voice if some copies can be made. And every now and again a blustery papyrologist bursts through the door, waves some scribbled-up letterhead in the air, and points a single chubby digit in the general direction of the fax machine. But it is begrudgingly that Gerry releases one of us to do the bidding of the faculty, because our charge, really, is to be decorative wastrels and personal henchmen—not to be subjugated by some hoity-toity scholar. Her Highness reserves a special scorn for any of her hires who takes it upon himself to tidy up too often or enthusiastically, or who becomes chummy with the faculty, or who attempts to devise methods through which he can legitimately contribute to the functionality of the office. Still, she periodically threatens us, one by one: "Hey you," she says, "you'd better start doing some more around here, or I'm gonna have to let you go." She reminds us that we are enjoying a free ride on the Gerry-go-round, and can be ejected at a moment's notice.

Like a self-fashioned tyrant from some lost John Waters film, Gerry uses the Department of Classics as a front for her own personal art factory. "Make me a song about poppers!" she recently commanded Theo, a twink with a knack for clever lyrics, catchy choruses, and audio production. "NOW!" she hollered. So Theo dutifully sat down at his swivel chair and penned a paean to the ever-popular inhalant. *Gerry Visco, popper-nation, feel that sweet sensation,* he typed. Later in the week Gerry,

THE GERRY PARTY

9 1

Theo, and an employee named Louis (usually the editorial twink), recorded a YouTube video of the finished canticle. Gerry stood in front of her framed Master's in Journalism diploma while reciting, over a jungle beat, "Rush it, huff it, breathe it, fuck it. Sniff it till it turns you on!" as various graduate students squabbled over an ambiguous passage in the *Iliad*, just outside the door.

Once I watched as Gerry summoned Harry, a freshman theater major and club kid, into her office. She set aside the tiny pair of scissors she'd been using to snip the excess from her rainbow stick-on nails, motioned him in, and sat up imperiously. "We had a deal," she said, rapping her fingers on her giant desk, like a mafia boss. "Have you done what I asked?"

"Ya, well—" he started, rolling his eyes and scratching at his own faux fur coat.

"You're workin' for me, now," she said.

"Um, technically, Gerry," he replied, "I am working for the Department of Classics . . ."

"What??" she screamed with outrage. "How dare you! NEVER say that again. YOU. WORK. FOR ME!" she barked, pressing both of her gleaming thumbnails into her breastplate. "Got that? You work for Gerry Visco. And GERRY VISCO asked you to write the first act of a musical called OLIVER TWINK. Now get out!"

The only staff member exempt from apprenticing at the Studio di Visco, is the temporary secretary, Jennifer Blowdryer, a

middle-aged punk singer and humorist who is absorbed by her own world. When the usual receptionist, Lila, went on maternity leave, Gerry turned to Jennifer, knowing that Jennifer not only had administrative experience but that she had even written on the subject, having penned a cult novella entitled *The Laziest Secretary in the World*. So these days Blowdryer sits at the entrance to the office, behind Lila's desk, speaking in stream of consciousness about Gore Vidal, a controversial new depression treatment that uses electromagnets, her friend Moonshine, the junkies she knows from Tompkins Square Park, and whatever and whoever else might come to mind. "I realized that I myself have become an East Village apartment," she informed me as I arrived one morning, "You know, sought-after but rundown."

"Quiet down out there!" Gerry yelled at Jennifer from the other room. "Don't distract me with that loud singsong voice of yours when I'm in the middle of trying to finish a new 'bitch track'!"

Once Gerry even held forth on a classical subject, with several twinks gathered around her. "Heliogabalus is my favorite emperor!" she declared. "He was a tranny hooker! You know that?

"Trans," one of the twinks corrected her language, half-playfully. "Trans . . . sex worker . . ."

"Yeah, a tranny! I wrote a report on him in high school. I had a major crush on Heliogabalus, like *oh my god*," Gerry waxed.

"Have you ever seen a bust of him? Let's just say the dude was good-looking. OK, he may have murdered some innocent people, but what emperor didn't? And he was only fourteen. It was a folly of youth. All I can say is he used to put on a wig and turn tricks on the street and in the imperial palace. Fabulous." She pulled a shining copy of Antonin Artaud's *Heliogabalus: Or, the Crowned Antichrist* from a mound of papers, wagged it in the air, and went on to explain that the emperor violated many Latin mores: he married a vestal virgin, founded a monotheistic sun cult, invited his mom to participate in the Roman senate— women were strictly forbidden—and appointed men of random vocations to high-ranking positions merely because they had big penises, perhaps as a way to both abuse and mock power. Clearly, Gerry has attempted to do the same thing in her own little kingdom. Her chief intoxicant is perhaps what another *favorite*, her favorite Italian director, Pier Paolo Pasolini, might have described as "the anarchy of power."

I am Gerry's favorite employee. I know this for several reasons. First, I have noticed she likes to "mark" me with pink lipprints on my cheeks whenever we say goodbye. Second, I have been entrusted with the honorable duty of making her write her memoir. "Could you threaten me with a gun?" she often asks. "I think that would speed up the process. I need to write this book so I can be taken more seriously in the world," she sighs. "Y'-know? You think I enjoy being this outrageous all the time? It's exhausting, actually. The memoir could reveal a certain . . .

depth." She pauses. "Of course, I don't actually give a shit about the writing. I mainly just want to show off during a book tour. Maybe that's why I'm having trouble focusing." She yanks a stack of papers from her bag. "What I really need is an amanuensis. Someone to follow me around and record what I say! Or maybe I should get the gun and make *you* write the thing!"

I also know I am Gerry's favorite because I am not allowed to leave her desk. Unlike Theo and Harry, who both used to wear their headphones in the other room, I must remain at her desk as Gerry's designated listener at all times. From where I'm sitting, Theo and Harry had a good thing going. But Theo got fed up with working for Gerry one day and stormed out, never to return, taking the paper towel holder with him. He needed to use it as a wig stand for his new drag persona. "My name is Hamm Samwich," the newborn queen announced on Facebook only days later. Shortly thereafter, Harry simply stopped coming in. He changed his name to Hari and became a *they* and then a *she* and then a star on the hit TV show *Transparent*.

I myself have not been reincarnated. Perhaps some blazing Tuesday I will change my name to *Geneva Convention* and leave it all behind. For now, I'm still languishing here in the office. I did storm out once myself, but Gerry chased me through the stairwell. Six flights down she threw herself on the ground and begged me to come back, sobbing, "I'd do anything for you!" At first I thought maybe she meant she'd do anything *to* me. But then again, whenever she gets a new computer or phone she al-

ways gives me her old one. She also takes me to concerts and operas, cooks me spaghetti, and reliably counseled me through a bad breakup over the course of many late nights on the phone. "You deserve better, Joseph. Relationships never work, believe me. Just go to a sex party instead." She can be a good friend.

And just as Gerry has been there for me, so am I expected to be there for her, not only as a friend, but as a worker. My duties are not confined to the office. Gerry encourages me to follow her into the night and around the city, especially if she has a gig or performance. For instance, she sometimes descends on Times Square with sacks of blonde wigs and lashes in order to dress people up like her, a process she calls *Gerrification*. "Gerrification, not gentrification!" she campaigns to hordes of baffled tourists. And last January I witnessed her onstage in the basement of a three-story nightclub, surrounded by her purses, absentmindedly stripping to a Lawrence Welk song. She kept dropping her light-up hair extension on the floor, bending over, and struggling to put it back on. Then she announced, "I want everyone to have a good year this year—will THIS help?" and quickly exposed her breasts.

"No!" someone in the back responded.

Sometimes Gerry even asks me or another employee to accompany her home after work to help her clean—or lately, to help her make more of a mess, since she is vying for a spot on the TV show *Hoarders*, and is convinced it may be her big break. (I think she has a pretty good shot, since her apartment,

even her bathtub, is filled with upside-down furniture and heaps of fluorescent clothing that change shape a little every day like sand dunes in the wind.) And Gerry *always* expects us staffers to help trick her into leaving the office so she can make it to her nightclub events at a reasonable hour, as she is certainly among the world's worst procrastinators. Motivated by a mysterious combination of optimism, thrill-seeking, and grandiosity, she prefers to wait until the last moment, when being on time somewhere will amount to a great victory against all odds.

Recently she was running late to a book release for the novelist Dale Peck, who apparently thought it would be a hoot to have Gerry emcee his event and 'open for him'—the reading was being held at music venue Le Poisson Rouge. I had unfortunately agreed to join her. "Why didn't you make me leave yet?" she yelled. "Now we're gonna be late. On the most important night of my career!" She popped her daily Adderall, swallowing it with a few swigs of bright blue mouthwash.

"You can't drink mouthwash!" I gasped.

"Of course I can."

Moments later, we were tearing across campus. Gerry was wearing a sleeveless evening gown, with a glistening multicolored bolero and an enormous baby-blue ribbon tied around her head. A few students stopped and gazed at her excitedly. "What are they lookin' at?" she fumed, marching out into oncoming traffic. A taxi honked at her. "Don't honk at me, stupid!" shouted Gerry, pointing at the driver and gritting her teeth.

"'Cause I'm *takin'* YOU!" She charged at the cab, throwing herself on its hood, using her purses as sandbags to weigh the car down. "Motherfucker!" she yelled at the driver, grabbing a windshield wiper as though it were the horn of a bull. "Get in!" she ordered me. As I pulled open the back door and slid in, I noticed a couple of students on the sidewalk, aghast. They probably wouldn't guess that this same woman had read every volume of *À la recherche du temps perdu* by age eleven, I thought.

"Here I am, baby buns!" Gerry announced to the driver as she slammed the door shut and gave one of her rape whistles a few toots. "And I'm going downtown. Think you can handle that? Huh, *baby buns*?" she taunted.

Some cabbies take umbrage when Gerry insults them, and many argue with her, while others quietly ignore her vituperation.

"I'll take you anywhere you want to go," this one replied, glancing at Gerry through the rearview mirror and raising his bushy eyebrows.

"How 'bout Florida?" she quipped.

"Anywhere at all," the driver repeated flirtatiously.

As the three of us barreled down Amsterdam Avenue, the driver occasionally laid on the horn for no apparent reason—though perhaps it was a sentimental reference to the circumstances of our initial encounter.

"Sir, do you have a honking problem?" Gerry asked him. She made "honking problem" sound like "drinking problem."

"Honking? I'm not honking!" the driver snickered. Two blocks later he did it again.

"Sir, are you crazy?" Gerry asked him. He just laughed.

As we pulled up to our destination, Gerry swiped her debit card, complaining, "I can't believe you're making me pay. I normally don't pay—I'm famous!"

Inside the club, readings were nearly underway. There were about fifty people in the room, chatting. Gerry took the microphone and silenced the crowd. She began reading the first page of her memoir, which began *I'm oral, not anal. My last name ends in a vowel. I'll sleep when I'm dead. I'm gangsta* and transitioned into a description of New York street culture in the seventies. But after a few moments, Gerry was flustered, perhaps worried that she was losing the attention of the crowd. Abandoning her essay, she began making bold announcements into the microphone. "I've slept with four thousand men! It's called 'busy'! Hey, I was raped three times! Don't you feel bad for me?" The audience gave no response. "Let's hit my track," she called to the DJ. Seconds later, the club beat to one of Gerry's songs, "The Gerry Party," came through the speakers. "I don't drink water!" she began, placing her hands on her hips. "I just drink gin! Yeah I'm crazy, but I always win." Gerry speak-sings rhythmically in a taunting voice. "Down with yuppies! They're super BO-RING! I'm out dancing while you're all SNORING! Join the Gerry Party!" she urged in a dainty, sexy manner. "JOIN THE GERRY PARTY!" she reiterated, this time yelling with all the un-

THE GERRY PARTY

bridled hostility of a communist dictator. I stayed in a shadowy corner during the spectacle, recalling that on her birthday last year, she socked me in the stomach when she saw that I wasn't dancing to her theme song.

As she sang Gerry moved like the boss at the end of the first level of a video game, tromping side to side, determined not to let the hero pass. Evoking both the political and convivial meanings of the word *party*, Gerry's coercive anthem serves as both a recruitment campaign and an invitation to indulge in the pleasures of anarchy; Gerry is a bully of fun. Like Auntie Mame, she recommends *Live, Live, Live!* but her tone of delivery is more akin to the bellicose style of the Misfits as they chant *Die! Die! Die!* She suddenly forgot the lyrics to the second verse of the song, even though it was about her. So she simply repeated, "Join the Gerry Party!" between interludes of stomping.

Sometimes I remind myself that I encountered Gerry's writing before encountering her. I think back to the little essay that I saved in a drawer because its writer, *anonymous,* was so honest and mysterious. I remind myself of the days I wondered who this soul was and what she was protecting. Little had I known I'd soon witness the woman in the flesh on "the most important night of her career," fumbling through a song of herself, anything but anonymous and as impervious to embarrassment as a person could be. Little did I know how embarrassed *I* would be by the spectacle, on my own behalf as well as hers. I am so often embarrassed by Gerry and I believe she intends me to be. Yet I

realize: her relentless transgressions, which mock herself and everything around her, make me feel safer in the world, more at home with my own eccentricities, social missteps, and excesses. Gerry is a terrorist-priest of the Church of the Ridiculous and it is my sanctuary.

Jennifer Blowdryer's guru Gore Vidal once said, "Having no talent is not enough." But as I watch Gerry, I know that talent would only get in her way. Onstage, her failure is wild. While she is able to embrace the chaos of the present, she remains unable to reckon with a disordered past. Gerry is often more character than author.

Blowdryer herself is ever reluctant to praise Gerry's literary efforts, but recently acknowledged her in another way. One day she remarked, from behind her Lazy Secretary desk in the Department of Classics, apropos of nothing, "When she dies you know what everyone will say, don't you?"

"What?" I asked.

"They'll all say, 'There was no one like her,'" she said, as if to imply that Gerry herself was something of an unsung classic. "That's what they'll say," she reiterated, nodding slowly. "But not *now*," she clarified with a melancholy smirk. "*Only* when she dies."

And I suppose Gerry is a classic, and that she's gotten in my head, and that must be why I, too, am singing her.

THE GERRY PARTY

KISSING

Our job was to kiss anyone who wanted a kiss. There were about ten of us kissers. We wore pinstripe suits and were each equipped with a tube of red lipstick, which was to be reapplied to our lips between appointments. Our clients filled out slips of paper, drawing circles around the types of kisses they wanted. The choices were: on the lips, on the cheek, on the neck, and French. I think "butterfly" was on there too. A client could request a hard kiss or a light kiss, a quick peck or a durational osculation. Also provided on the slip was a fill-in-the-blank section, in case clients wished to detail special instructions or to jot down some meaningful sentence they'd like to hear whispered into their ears. A client could select which kisser he or she wanted, or be randomly assigned to one of us by the Kiss Coordinator, an unassuming woman who sat at a small desk near the entrance. We kissers were not paid.

Erin and I had driven over from Ann Arbor to Chicago to participate in this guy Cameron's MFA thesis project, the "kissing company" I've described. I don't know if his purpose was to illuminate a connection between romance and consumerism, or to envision a future in which prostitution had been corpora-

tized, or if he was simply spurred by an impish desire to facilitate a public game of spin the bottle under the auspices of art. I didn't wonder about it; I just kissed.

The day was easy. We kissers each had our own little booth. I don't think that even one person asked for a tongue kiss. The Chicago art public didn't strike me as very adventuresome, frankly. David Mamet may say there's sexual perversity in the Windy City, but I don't believe him. I would have rather gone to third base—to the foul zone, for that matter—with a person I found unappealing than to have doled out the bedtime kisses everyone kept asking me for. Obviously, these people felt differently. Did they have no curiosity? Were they really making the most of the situation? Not the way I saw it. Maybe they were all committed monogamists or germophobes. Maybe they needed comfort more than anything. Maybe there's a deficit of desire in Chicago.

Erin and I were boyfriend and girlfriend but we didn't call it that. We didn't call it anything. We made out on the damp floors of gay bars, had sex up against the chalkboards of empty classrooms in the middle of the day, and slapped each other in the face for fun. When Erin blurted out "I love you" one night when we were trashed on vodka, a look of shock appeared on her albescent face, as if she'd spilled a dirty secret or muttered a slur. In a way, she had. See, all those words had too much baggage for us. You know those words. Gay. Straight. Bisexual. Queer. Boy. Girl. Trans. Love. In Love. I viewed them as flawed concepts,

lexical snares. Trinkets masquerading as treasures, whose true lack of value would be revealed on some great day of reckoning, on the *Antiques Roadshow* of existence. Words that didn't honestly describe the complexity of human experience so much as they confused it.

"Whatever," our gay friend Jim had laughed one night when we tried to explain to him that our sex was still *queer* even though we didn't have the same sexual organs as one another.

"We have an open relationship," Erin had pointed out. "I do what, and who, I feel like doing."

"We're non-gender conforming," I'd added, fingering a lock of my voluminous tresses.

"Gender nonconforming," corrected Erin.

Jim had had none of it. "Heteros!" he'd ridiculed, throwing his head back to swallow the remainder of his emerald-colored appletini with one bold sip.

Erin and I were younger than most of the other agents in the corporate kissing booths. We were only sophomores in college and they were all grad students, it seemed. We didn't know them. We didn't really know Cameron either. We'd met him in Ann Arbor at a conference or maybe on the outskirts of an orgy —I can't remember. When he asked us to participate in his project, we said sure.

At the end of the day we went over to Cameron's place for a party. It was a house party, with loud music. As I pumped beer from the keg for Erin and me, I looked above the refrigerator

and saw a poster of a Jim Dine painting that made me think of stained glass. There was almost no furniture in the apartment. The people at the party were mostly Cameron's classmates, straight graduate students from the School of the Art Institute of Chicago.

The night was uneventful. At 2 a.m. Erin and I decided to turn in. One of Cameron's roommates was out of town, so Cameron had told us we could stay in her room.

Erin and I started cuddling. We both felt like having sex, so I grabbed a condom from the front zipper-pocket of my backpack and then we had sex before falling asleep. We woke up the next day around noon as Cameron rapped on the door. He was asking, "Do you guys want to go to brunch now?"

"Yeah," my and Erin's voices overlapped, both scratchy in the way voices are in the morning.

"OK, lovely," Cameron said. "Ten minutes?"

"Sure," Erin answered. Naturally, we proceeded to sleep for another ten minutes. Eventually I slid out of bed and began fishing around for my clothes.

"We're almost ready! Just one sec!" I croaked in no particular direction.

"OK!" Cameron answered. Erin squinted and reached down, pulling the condom wrapper from the night before off of her thigh. She turned her head to the right and then to the left.

"Where did you put the condom?" she asked.

"Probably on the floor," I said. We both scanned the floor. "I

KISSING

105

guess it must be in the bed." Erin got up and pulled back the sheet. She felt underneath the pillows.

I looked at the side of the mattress, in case the condom had gotten stuck in the crack between it and the bedframe.

"It should be easy to see," I said. "It was one of those black ones." We had gotten a handful of black condoms from a basket at Aut, the Ann Arbor gay bar. They were ugly but they were free. I preferred clear condoms, the kind that say *Oh, don't mind me. Pretend I'm not even here!* Brightly colored condoms, on the other hand, have always seemed like they are intended for children. Products that come in a variety of intensely saturated hues often are, one must admit—they should come in the bottom of cereal boxes—a "Collect All 7!" sort of deal. And black. Black condoms strike me as though they are supposed to be somehow *kinkier* than other condoms, perhaps having been designed to match the getups and paraphernalia preferred by members of the leather and fetish communities.

"Is it stuck to one of our bodies?" I asked Erin. We both examined one another and turned around. Erin was still naked and I was in my underwear. No condom.

"It's probably under some of our clothes," she said. "Let's get dressed."

We took our clothes off before *using the condom last night*, I thought. But she was probably right. Things always get lost and buried, inexplicably, in and around beds.

We carefully picked each of our garments from the floor, shook it, turned it inside out, and put it back on our bodies.

"Let's strip the mattress," Erin said once we were fully dressed.

"OK," I agreed. "It's probably the polite thing to do anyway," I remarked. "You know, to fold the bedding."

"Really? I guess." Erin said, already uprooting the top sheet and shaking it over the floor. I yanked out the bottom one, flung it into the air, caught it and shook it too. Erin removed the pillows from their pillowcases. She handled each delicately, as if she were inspecting evidence at the scene of a crime. We folded every item of bedding and placed each on the nightstand, before kneeling down to search under the bed.

"Are you guys about ready??" Cameron asked through the door.

"Ye-us!" Erin answered in an over-the-top voice that might have belonged to an effete Southern plantation owner. She was acting playful to mask her ensuing panic. "It's going to be so embarrassing when Cameron's roommate finds it," she whispered.

"Or when Cameron comes in to check the room and finds it," I said. Suddenly the notion of leaving a used condom in someone else's room struck me as unconscionable. The ultimate act of rudeness on the part of a guest. Petrified, I overturned a rug for the third time. Erin examined the bottoms of our shoes.

Now we were both worked into a feverish state. I walked over

and fiddled with the venetian blinds to see if the condom might have "gotten in there." I ran my fingers over the windowsill. Erin made sure the condom wasn't stuck in her hair.

This was it, I couldn't stand it. The damned thing had to be somewhere. Without thinking I began pulling books of the shelf and opening them, shaking out their pages. Erin joined me. A receipt fell out of a Don DeLillo novel. "Check *Mrs. Dalloway*," I panted. "It's not in *Frankenstein*." There were only about a hundred books. We opened each one. Tolstoy, Beatrix Potter, Foucault, Jeanette Winterson: all empty. The diaphanous pages of *The American Heritage Dictionary* were disappointingly pristine. No surprises in *Cat on a Hot Tin Roof.* We jostled *The Indigo Girls Songbook* with vigor and hope, but for nothing.

"OK. Let's make up a story," I said.

"Like what?" Erin asked.

"Like . . . let's say there was some weird drunk couple in the room and we had to kick them out when we went to bed. You know? Like they had sneaked in there and screwed in the middle of the party. There were a lot people here last night . . . we won't pin it on anyone specific, but when Cameron finds the condom he'll think it's theirs, this mystery pair . . ."

Before Erin could respond Cameron opened the door and simply said ". . . Hi." He had a tight, irritated expression on his face.

"We're ready!" Erin announced.

The three of us had brunch at a popular restaurant in Boys-

town. Erin and Cameron were doing most of the talking. I was still preoccupied by the condom. I waited for the right moment to tell Cameron the fib I'd devised. I swallowed a sip of coffee.

"So who was that hipster couple?" I asked.

"Hipster couple?" Cameron repeated quizzically.

"Yeah, there was this couple in our room when we went in there to sleep last night. They were making out or something." I glanced to Erin for corroboration, but she didn't do or say anything. Cameron looked confused.

"Their names were Erin and Joseph!" Erin suddenly interjected. "Ever heard of 'em?"

"What?" Cameron laughed.

"Do we know what we want?" the waitress interrupted.

As I ordered a cream-cheese-and-spinach omelet, I forgot about the missing condom and about the lie I'd been in the middle of telling. The conversation shifted to other topics.

After we finished brunch Erin and I said goodbye to Cameron and drove the five hours back to Ann Arbor.

Two days later Erin and I were hurrying through the parking garage of the apartment building where we lived. Both of us were late for class. Erin froze abruptly as I continued to walk several steps ahead of her. When she shrieked I turned around. She was holding the elastic waistband of her black dance pants away from her body with one hand. With her other hand Erin was reaching down her underpants. She was staring down her pants. She slowly pulled a dark, gelatinous strand from between her

legs. A thick, slick discharge was coming from inside her. It was a worm. No, it was an orgy of parasites. It was oil-colored blood, untouched by oxygen, that had congealed deep within the body. The sign of a fatal disease. It was an alien infestation. It was something rotten, something foreign, a luminous viscous band of toxic goo that should never be inside a person.

It took us three terrible seconds to recognize the mysterious substance as the missing black condom. She sighed. I laughed in quick, desperate spurts. She dangled the condom between our faces like a string of pearls. We were relieved, until we realized that my sperm was inside her too.

I whispered, "You could be . . ."

"Preggers," she finished the sentence.

We skipped class. Erin called Jim to ask him what to do. I don't know why a gay man would be the go-to on a pregnancy scare. But Jim knew a lot of tips on safe sex. He seemed to be an expert on sexually transmitted diseases, and Erin and I lumped pregnancy into that category. She put him on speakerphone and explained what had happened. "I can't WAIT to meet Queer Sex Junior!" Jim exclaimed with delight. He went on to instruct us to go to Planned Parenthood and get a "morning after." An abortion pill. As soon as she hung up with Jim she called the clinic and scheduled a same-day appointment.

Then one of us—I don't remember who—said it. *When we go there we have to pretend to be straight.* Why would a Planned Parenthood nurse assume that a male and female coming in to re-

quest a morning-after pill would be anything other than hetero-sexual? Why would it make any difference what her assumptions were?

Perhaps Erin and I believed if we acted too light in the loafers the nurse would think it a prank and deny us the little tablet. Perhaps we viewed our partnership as a gag we'd been playing on the tyranny of sexual category. Maybe we just wanted to distract ourselves from the reality of the event, or maybe we wanted to make it fun. Maybe we wanted everything to be a performance.

"So what sort of couple are we?" Erin asked as we were deciding what to wear. The question went unanswered. Gravely, I buttoned up a flannel shirt. I slid my long white feet into a pair of work boots. Erin put on eyeliner and blush and a grape-colored sweatshirt. She pulled a short denim skirt over her black leggings.

"You just look really eighties," I said.

"Eighties straighties," she replied, teasing her hair out with a beige comb.

I even went so far as to put on a red baseball cap backwards. But then I took it off in the car before we went into the clinic. It just struck me as too absurd when I looked at myself in the rearview mirror.

We would never know if Erin had actually been pregnant or not. Still, for months Jim would teasingly ask us how "Queer Sex Junior" was doing. Was the child potty-trained, how was the kid doing in school, what colleges were on the horizon for in-

dustrious young Queer Sex? Like many imaginary children, ours was at once many ages.

The woman at Planned Parenthood was professional. She didn't inquire about my or Erin's sexual identity, or question the veracity of our claim. Erin swallowed the pill with a gulp of water from the drinking fountain. It cost thirty dollars and I paid.

X

Ever wonder where a rainbow goes? In its afterlife, a rainbow hardens into a nugget of radiant filth and falls from the sky. As it descends into the ghetto of solid matter, the rainbow becomes *ugly*, as only solid forms can be; light, gas, and water are simply incapable. Finally, surrounded by a chain-link fence, this foul lump congregates with all the other fallen rainbows to create a garden of putrescence in the center of Plainwell, Michigan.

Haley Strayer lived on Morrell Street in a small blue house. Her lawn was strewn with mounds of swirling colors because her dog Marbles routinely ate Crayola crayons and then limped around the yard expelling them.

I met Haley during the summer on the first day of "Odyssey of the Mind," an extra-curricular, creative problem-solving club. Haley was lanky, with chin-length brown hair. I immediately noticed her black *X-Files* t-shirt, which was tucked neatly into her slim-fitting tapered blue jeans. The back of her shirt read "The Truth is Out There." *The X-Files* happened to be my favorite television show at the time. I had spent the past year of Friday nights loyally watching the program.

"Hey, I like your shirt," I said to Haley.

"Thanks," Haley said. "You look kind of like Mulder, actually." She spoke in a low tone for a girl, with a matter-of-fact delivery, like a college techie guy. "Has anyone ever told you that?"

No one had, in fact, told me that I resembled the dashing male protagonist of *The X-Files*, an FBI agent who investigated government conspiracy and paranormal occurrence. There were a number of differences between us. For instance, while Mulder sported rather flattering suits, I preferred to be seen sauntering down the halls of Plainwell Middle School in an oversized, tie-dyed dragon t-shirt, a pair of lime-green shorts with a wide, sewn-in belt, and cobalt slip-on pool shoes—"aquasocks" they were called, as some classmates informed me one afternoon, in the midst of their ridicule.

"You know it *is* Friday," Haley stated perkily, raising her finger as though she were sharing some nifty tidbit of scientific trivia. "Do you want to watch it together?"

"Sure," I replied eagerly. So when Odyssey of the Mind finished, the two of us traipsed to her house and enjoyed the first of our soon-to-be regular *X-Files* nights.

"Do you like O.M. so far?" I asked her as we crossed a small bridge over the Kalamazoo River.

"Yeah, it's pretty cool," she said. "Back when my cousins did it, it was called 'Olympics of the Mind,' but the real Olympics sued. So they had to change it."

"'Odyssey' sounds, like, less competitive," I remarked.

"Yeah, more open-ended," she said.

X

"Everybody just calls it by its initials anyway," I shrugged.

"Careful," Haley advised as she pushed open the croaking gate to her yard and pointed to the scattered, colorful poop. "Marbles eats crayons," she explained. Leading the way to her front door, she added, "She used to eat marbles." I tiptoed after her through the murky wonderland of Marbles's speckled gifts.

As the eerie, minor 6th-spiked arpeggios of the *X-Files* theme music rang out from the television, Haley and I sat cross-legged on her brown carpet. Our hands were already stained orange from reaching into the bowl of cheese-powdered popcorn that sat between us. Our eyes were instantly transfixed by the medley of blazing occult symbols, distorted faces, and hovering space-craft that appeared on the TV's gleaming screen.

"I wonder which episode it will be," I remarked quietly. "I wish they played new ones in summer."

"I know," said Haley. "I've seen them all."

"Me too," I said.

To our mutual surprise, the show that unfolded before Haley and me was one neither of us recalled having seen before. In this particular episode the two FBI special agents—the afore-mentioned (Fox) Mulder and his equally striking female partner, the fiery-haired (Dana) Scully—travel to a small town of circus freaks to investigate an especially violent series of murders. There they meet a human blockhead, a silent geek who has tat-toos all over his body and devours live animals, and various other memorable specialists of unsettling behavior. All of them

x

are suspects. Mulder entertains the notion that "the Fiji mermaid," a hoax specimen, made from a monkey torso sewn to a fish tail, might have sprung to life and gone on a killing spree. At the end, Scully and Mulder uncover the equally outlandish truth. It turns out that Leonard, the fetal conjoined twin of Lanny (a mild-mannered alcoholic with a melancholy aura) is able to detach from his brother's belly for brief periods of time and has been scampering around, burrowing into the other circus folk and eviscerating them. Not because he wants to *kill* them, we learn, but because he wants to become a *part* of them —he is searching for a new twin.

As I left her house that evening, Haley handed me a holographic decal with an electric green "X" on it. She'd probably gotten it from a cereal box or something.

"I have an extra," she said gruffly.

"Really? Thanks," I said, rotating the sticker in my hand to make the image disappear and reappear. "I'm going to pretend it's kryptonite or a powerful amulet that releases bolts of energy when I want it to."

"Good idea," she said.

As I walked back to my house, I fiddled with the sticker and thought about the letter *X*. In the show, the documents in question—the eponymous files—consist of top-secret government papers that detail paranormal occurrences and hold potential clues about the existence of alien life. Is *X* about the mystery or confidentiality? I wondered. *X* also means *condemned* when

x

painted on doors, I remembered, *treasure* when scrawled on a map, *forbidden* when rating a movie, and *dead* when drawn across the eyes of an unfortunate cartoon character. As I'd recently gathered in algebra class, *X* was a shifty character that concealed a different value each time you were confronted by a new equation.

Haley and I continued our Friday meetings through the summer and into the fall. But suddenly, smack-dab in the middle of eighth grade—and halfway through the *X-Files* season—she transferred schools.

"I'm moving," she told me one day when we ran into each other in the parking lot outside Sigg's Party Store.

"Really?" I bit into the candy cigarette in my mouth.

"Yeah. To my dad's place in Kalamazoo." Kalamazoo was the relative metropolis, fifteen minutes from Plainwell. "I have to go. I'll be back to visit my mom some weekends . . . I'll give you my new number," she promised. But she never did.

Through the eighth-grade year, I was left to watch *The X-Files* alone. I walked past Haley's house on the way home from school, registering her absence. I never saw Marbles running around outside, but I observed daily additions to the ever-changing action painting taking place on the lawn.

During this period I, like many middle schoolers, endured increasing torment from my peers. I was routinely locked out of classrooms by the other kids, spat at on the street, received the occasional death threat, was treated to one individual smearing

X

his blood all over my drumsticks (I was learning to be a drummer). One day Julie, a girl I had a crush on, pointed to the vampire on my t-shirt and remarked, with severity, "That's what you look like."

"Yeah, get a ta-an!" squealed her friend Tara.

Before, I'd always tried to stand up for outcasts, but now that I was one I noticed myself becoming nervous about my associations. Adding to the peer-inflicted torture, which made me self-conscious enough, the Plainwell Middle School administration installed mirrors throughout all the hallways. These mirrors had a slight funhouse quality. They reflected subtle distortions. Namely, they made everyone look a little shorter and a bit wider. And lest one want to hurry past his or her uncomely doppelganger, Ms. Vaughan, the hall monitor, would blow a shrill whistle and issue a detention, on-the-spot, for "walking too fast." So I, along with other students of Plainwell Middle School, was forced to proceed down the halls at a funereal pace, in constant contemplation of my own grotesqueness.

At home I didn't just watch *The X-Files*. I began to immerse myself in all sorts of new TV shows—detective shows, sitcoms, cartoons, and a science fiction program about time-traveling children. Reruns too—*Laverne & Shirley*, *The Beverly Hillbillies*. I left myself on the sofa and escaped into TV lives. I watched the *X-Men* animated series and fantasized that I was a mutant too. I imagined that I was being ostracized and punished because I had *powers*. I lay in my sleigh bed at night and concen-

x

trated as hard as I could in an attempt to levitate the clock above the dresser and float my body above the bed. During the onset of thunderstorms, I took to marching out to the front porch and raising my arms, believing that I had the ability to summon greater gusts of wind.

At the end of the school year I began to change my look. I decided to do this when I was in the shower one day. *I will change,* I vowed. *I will become confident and normal.* I went shopping at the sporting goods outlet. *Baggy is 'in,'* I had suddenly noticed, years into the trend. So I found a loose-fitting, short-sleeved rugby shirt. The next day in band class, as my peers compared it to a maternity gown, I learned that the shirt was in fact *too* baggy. Back in the shower I made a new decision. "I am strange," I uttered in a dead tone. *I will become stranger.*

By the first day of ninth grade, carrying out my plan to make eccentricity my super-power, I was drawing tiger stripes on my jeans with a sharpie. I began wearing tribal necklaces, satanic rings, plus-sized women's clothing from Target and TJ Maxx (roomy on me), purple lipstick, garlands of dead leaves, a Nepalese hat festooned with trinkets, rotary telephone cords, and chains. I was becoming a *cyber gypsy.* I would say everything that could be said about myself before anyone else did.

On the Saturday after the first week of ninth grade, I got my mom to drive me into downtown Kalamazoo and drop me off, so I could go to record stores—Flipside and Repeat the Beat—the head shop, Terrapin, and my new favorite countercultural

x

outlet, Through the Looking Glass. The boutique had a black and white checkered floor, mirrored walls (which displayed flattering reflections), and several small rooms. They sold hair dye, chain mail, vinyl pants (in black, red, and silver), striped tights, and various metal and leather accoutrements, which were more chic than the budget bondage-wear I had found in the Kmart pet department. Through a curtain was Through the Looking Glass's sister store, a thrift shop called Planet Clare.

As I stood at the glass case in the back, eyeing the eyeball rings, I heard a voice that was at once familiar and unfamiliar. I looked over and saw Haley Strayer from behind. At least I thought it was Haley Strayer. She was talking to the clerk. Her hair was longer and in a ponytail. Her clothes were looser-fitting than before.

"Haley?" I called quietly. She turned around and nodded nonchalantly.

"Hey," she said. "That's not my name anymore." Her voice was hoarse now, and possessed a new element of femininity. She spoke with a sultry aloofness. She brushed a wisp of hair from her face and turned back toward the clerk. "People call me Buzzy now."

"Oh," I said, searching for something more to say. Maybe she didn't recognize me, what with my new style and all the impressive trinkets hanging off my clothes. I opened my mouth and waited for the right words to come. "Have you . . . have you seen *The X-Files* lately?"

X

She looked at me blankly before replying flatly, "I don't watch TV."

Buzzy didn't watch TV.

This news took the air out of me to the point that I could barely choke out "see you" as I watched her exit Through the Looking Glass moments later. The Haley I'd known was no longer. She floated into an outsider echelon I could but dimly comprehend. The real possibility of not watching television— let alone the *act of abnegation*—had never occurred to me. On the car ride home, I sat in silence next to my mother, looking out the window at passing cornfields, railroad tracks, and woods. Though I had felt the sting of rejection back at the store, I was more deeply shaken by her claim that she'd abandoned the tube.

A couple weeks later after school one day, I plopped down on the couch and turned on a superhero cartoon show, as was my custom. I barely perceived the change that was underway inside of me, a change ignited by Buzzy. On the first commercial break, I watched an ad for little marinara-and-cheese-topped bagels. The jingle exhorted me to eat pizza in the morning, evening, and suppertime. Then, in accordance with some strange logic, it promised me that when pizza was on a bagel, I could indeed have pizza *anytime*. What's that you say? Evening *and* supper-time? If I'm throwing dietary caution to the wind, could I not go ahead and eat *pizza* itself anytime? Or for such a reality to arise must pizza be fused to bagel, passing through some loophole in the grand order of all things? I watched the next com-

X

mercial. A yellow pail with a face, aptly named "Mr. Bucket," was firing colored balls from out of its mouth at giddy tots. The theme song featured a dopey clown voice repeating the name "Mr. Bucket" many times. Seized by a new and bold urge, I took the remote control in my right hand. I held it. The faded actress Sally Struthers then materialized onscreen to endorse a mail-order adult education program. *Do you want to make more money?* she asked the mute viewer. *Sure, we all do*, she continued plaintively, replying to her own question. My palm was dry and my grip was steady. The power button was under my thumb. Just as my cartoon resumed, I pressed it.

I zapped the superheroes away. Bucket and Struthers would live on in memory only, glowing faintly like maimed fireflies. I marched right upstairs, played Dido's Lament on my Walmart boom box, and began to draw. Rather than invent another super villain (I had hundreds already), I crouched in front of the mirror and drafted a smudgy self-portrait in charcoal on a paper bag from the family grocery store. I carefully elongated my face and exaggerated the shadow around my eyes, an extra dose of morose. Once it was complete I came down the stairs to lurk outside the little TV room, my hands still black and dusty, as my mother and brother watched Jeopardy. Wouldn't I like to come in? Sorry kiddos, I'm an artist now!

I adopted an ascetic practice in attempts to retrain my desire; I began walking out of rooms with televisions, as though each

x

TV set were a scorned ex I refused to acknowledge. Then I almost died—maybe it was due to shock of withdrawal from popular culture. Or maybe I was allergic to the first joint I soon smoked, handed to me by an older kid with greasy hair and a Megadeth t-shirt who bayed "stoners gonna rule the world" at the bonfire—his promise was no more appealing or reliable than that of the pizza-bagels—but mere weeks after my renunciation of TV, my appendix ruptured. I let the pain go for a couple days, but one night became delirious, believing myself to be a statue that had broken in half and washed up on the shore. Hearing my somniloquent babbling from the hallway, my mother, whose name is not Melissa, came into my bedroom. "Melissa?" I called listlessly. "Is that you?"

A blurry week and a half in the children's ward of the hospital marked a type of rebirth. I guess my body was just feeble, but I felt like I was relearning to walk as a nurse took me into the hallway each day, holding my shoulders as I tried a few more steps than the day before. When I was released and recuperating back at home it didn't even occur to me to pass the time with TV. The impulse was gone.

I didn't fully understand why, but it was a relief not to watch it. I didn't miss the phony humor on sitcoms, or the talent contests that seemed to be predicated on the sinister imperative of *elimination*. Why had I often felt a space close within me when I watched TV, but felt something open up inside when I viewed

x

certain old paintings or films? Perhaps because television shows are episodic and designed to continue endlessly, I reasoned, they must provide their audience with both an ailment and a cure. I realized that when I'd watched television I always desired, intensely, to be inside it. Does everyone? I wanted to be those characters so much that I found my own existence intolerable. Then I'd watch more, out of a compulsion to emergency-evacuate my own life. I wondered if reality shows emerged as an answer to this restless anxiety to be inside the TV, promising as it did a point of entry for the viewer.

I rolled through the rest of my teens and early adult life not understanding the references my peers made. I had no clue Who Wanted to Be a Millionaire and could not recognize American Idols. I was pop culturally out-of-it but not so admirably monastic, as I would still become addicted to the Internet, despite the advice of an old man who hung out by the river one winter seeing endless visions of saints in a snowman he built, and regularly warning me that the digital world was a "psychological sticky spider web."

I returned to school within weeks of my appendectomy, but it took a couple months for me to recover. As I learned to re-inhabit my body, I also wished to escape it. My sense of longing was now untied from television, but did not disappear or dissipate. Personalities in my daily life would come to replace prime-time characters and I would want to burrow into them, like Leonard the restless fetal twin.

X

And just as I'd designed a new incarnation for myself that day in the shower, dreaming up all the unnecessary apparel I could wrestle myself into, I went on plotting outlandish transformations. None were practical and many were impossible. Out at concerts with friends, for instance, I would sometimes become stiff and nervous and then suddenly wish that my body would liquefy, so that I could trickle right out of the club. And often I lay in bed at night, looking up at the glowing stars on the ceiling and out the windows at the orange smoke of the paper mill. Then I'd close my eyes and happily imagine that by morning my entire body might become a vapor. This was the lullaby I sang myself. I fantasized about bursting into a gas the way one might entertain visions of becoming a famous actor. It felt like a modest dream at the time. I can still see it now: I'm transubstantiating and exceeding the room, rising high above Plainwell to become an atmosphere unto myself, a hovering swarm of droplets filtering the light.

X

FIJI MERMAID

There is a bus in Brooklyn called the B24. I must warn you about this bus. While it travels from Williamsburg to the nearby neighborhood of Greenpoint, it takes a rather tortuous route. On my first ride, it appeared to roll through New Jersey, Yonkers, and several unsavory alternate dimensions before arriving at my destination. On the way, it passed under a highway at a desolate intersection that felt to me like The Crossroads, though perhaps not a crossroads where you could make a deal with the devil. More like a crossroads where you've made an appointment with the devil but he stands you up. There is a McDonald's there, with a pagoda. It is the McDonald's at the edge of the world.

After passing by this strange landscape that hummed with emptiness, I couldn't get the place out of my head. Every couple of months, when I would decide to go for a walk, I would always end up trying to locate the intersection on foot, yet I never could. This encouraged my belief that the McDonald's and the elevated highway belonged to a netherworld that could be accessed only at certain times by way of the suspicious B24.

The next time I rode the B24, on my way to meet a friend in

Greenpoint, I did not see the intersection. But the time after that, a day when I truthfully had no particular destination, the McDonald's appeared to me.

I hurriedly pressed the "stop" button and exited the bus. I crept through the parking lot under the highway, stood in the shade, and watched as several people came out with their paper sacks of food. They all turned corners and disappeared. The landscape felt desolate still, but a little less mysterious now that I was not viewing it in passing, through the windows of the bus. Determined to get my bearings, to place this corner geographically, I began walking. I was certain I would soon encounter a familiar avenue.

After walking by the McDonald's I came to a tidy residential street, populated by quaint one-story buildings, with various colors of siding. A melody emanated from one of the homes. Perhaps someone is singing while doing chores in her kitchen, I thought.

As the melody repeated, I could hear that there were words, and it sounded like an advertisement. "Cool and shady!" the voice was saying. "Cool and shady!" with *cool* on the lowest pitch, *shay* on the highest, and *dee* settling in the middle. As I said, the refrain was like a commercial, an enticement, like the kind the guys who sell "ice cold water" use on very hot days. Only this voice was feminine and bubbled with a certain eagerness.

Moments before, the voice seemed to be ahead of me, but

now it seemed to be behind. So I turned around and walked in the direction of its source. I saw a very narrow brick building, squished in between two wider homes. The door was open and I could make out a small figure standing inside.

"Hey!" came a whisper from the door. "Y'lookin' for meee?"

"Oh no," I replied, defensively. "I am just going for a walk." I assumed this person must be a prostitute or drug dealer. I was sure I appeared aimless, or like I was looking for something that I was not.

"You took the bus here," the voice said, still whispering, as though we were two subordinates hatching a plan against our boss.

"Yes," I said, in the sort of voice I would use on a professional phone call. "I have never seen this part of town before, and it looked interesting out the window."

"You came to see me," the voice insisted. "Get over here! Quick! Quick!"

I don't like being ordered around, especially by strange figures lurking in doorways, so I hastily began walking away. But the figure then resumed communicating through its sweet, warbling soprano, now singing a little capriccio based around the "cool and shady" theme, it seemed, but without words.

Exasperated, yet intrigued, I turned back around and approached the doorway. For a moment, I saw a little girl. Appearing startled, she dropped something, and little shiny balls scattered across the floor. "Oh heavens! My beads!" she gasped. I

could see that there were multi-colored round beads on the floor, the cheap kind you get at Mardis Gras.

Instinctively, I stepped forward and knelt down to help pick them up. The door shut behind me. I turned around, but the girl had already scuttled into her kitchen, through a beaded curtain. The apartment was decorated like a bordello—little velvet cushions, lamps with dangling tassels. There were garlands, beaded nets, wind chimes—it was a room where many things dangled.

Still clutching a handful of the cheap beads in my right hand, I rose to my feet, and with my left hand, groped around behind me for the doorknob, fixing my gaze on the darkened kitchen.

A furry hand emerged through the beaded curtain, and the figure finally appeared, humming. Though only about 3 feet high, she was not a little girl at all. She had the head, arms, and torso of a monkey, and the scaly tail of a fish. At her waist were crude stitch marks. She was able to stand upright and waddle around—rather quickly, too—with her tail curved, partially dragging on the floor. Her tail looked chaffed and scabby, no doubt from being scraped against the Oriental rug. The figure's wrists were decorated with several bracelets that jingled as she moved. She wore a shredded green ribbon, which crossed her breast diagonally, from shoulder to waist, like that of a pageant queen. But this ribbon bore no words.

Whenever she stopped humming for a moment, fear and nausea began welling up inside me, but then as she resumed, I re-

ceded into a calm and observant state of mind. "Take a seat," the grotesque siren whispered in between phrases, gesturing toward a fuzzy, beanie bag seat on the floor, nearby. I sat down. She moved with pomp and circumstance to the far side of the room, like a slug at its coronation. She knelt over to plug in some Christmas lights, and two desk lamps that were arranged as spotlights. One shone in the center of the room, and the other illuminated a placard. *The Fiji Mermaid*, it read, with a little pen and ink drawing of my hostess. *A sideshow hoax, once exhibited as the mummified remains of a rare creature by circus impresario P. T. Barnum. The hoax was later exposed.*

The figure slithered into the other spotlight, ceased humming, took a breath, and delivered the following song, part torch ballad and part self-declarative anthem.

During the song she behaved in a manner by turns seductive, threatening, and forlorn.

> *I am*
> *the Fiji Mermaid*
> *I come from a need-le*
> *I've got some invisible eyes*
>
> *have you?*
> *had walls around you?*
> *did you*
> *ever live three lives?*

FIJI MERMAID

I've been
a restless creature
a fish out of water, dangling
above a sea of fools

No one
knows we're here
Don't tell them
I'm here

I could not stop you if I tried

Stay here
It's cool
inside

She closed her eyes and stood still for a moment and then snapped awake with a flourish, swirling her hand/paw in the air as though it were smoke rising. She gestured toward the door, dismissing me.

Since she was no longer singing, my heart began racing, and I felt ill. Far from being able to process what I had just witnessed, I suddenly wished for nothing more than for her to continue singing. I felt torn inside, as though my lungs and stomach were being gnawed at by an organism. It was cruel of her to stop singing. I staggered toward the door.

"Never tell, never tell," she hissed, pushing me out to the

FIJI MERMAID

street. I stumbled onto the sidewalk, clutching my chest. I took several steps away from her building and stood to collect myself. My pain subsided, and I set out in a random direction. I walked through the sunny streets of Brooklyn, in a hazy, stunned condition. Although I was no longer thinking about my location, only sensing my relief, I managed to find my way back home.

I do not take the B24 anymore. And I don't go looking for that McDonald's. You could say I avoid the area, though I'm still unclear where it is, geographically speaking, and so I can't truly avoid it. I am sometimes haunted by the Fiji Mermaid's song and have often wondered if the experience actually happened, and if it did, what her motive was: in exhibiting herself to me in such a way, in luring me in, and in singing me such a song. The whole encounter was like a disturbing "pop-up show," ever popular these days in Brooklyn, I suppose, but normally more innocuous than my experience that afternoon.

I guess what the Fiji Mermaid wanted, more than anything, was for me to keep her secret. And I did, for several years. I told no one—lest they question my sanity! Anyway, I doubt she's hanging out behind the McDonald's these days—I'm sure she's found another hideout. And I really did keep her secret for a long time. Her secret, that she was real.

ANDRAGON

People always ask me, "Where are you from?"

I say "Kalamazoo."

They say, "No. I mean where are you from?" In my twenty-one years I've been mistaken for a variety of ethnic identities, including Chinese, Italian, Native American, Latino, and Cher. I'm just white, but it's somehow abstracted. So I've come to think of myself as an ethnic wildcard, a Choose Your Own Adventure, a venue for projection and portraiture.

Is it just my looks? My elbow-length black hair and oversized lips? Are two features all it's taken for me to have become a stand-in for Asians, those of Mediterranean descent, and various indigenous peoples? Is this simply because those groups have so little visibility in the Michigan towns I've been living in? Yes, perhaps. Yet I probably encourage these exotic readings in the way I dress: often formally, sometimes scantily. You know, three-piece suits, grass skirts.

I guess I also come off as foreign because I don't have a strict Midwestern accent. I'm more "expressive." This means that I complete sentences. See, Michigan men normally toe the line between being laconic and being dead. Most barely utter a word.

They just tap their feet and release a few *er*s, *well*s, and *but*s through their teeth like stifled after-dinner burps. You know the type of guys I mean—all discourse markers and no discourse. And in the Midwestern vernacular, everyone chokes their words, sticks close to the consonants. Pop. Grocery. Tanner. Pp. Grcry. Tnner. Vowels have no futures here. In Michigan our vowels are stillborn.

I let my open sounds hang in the air. I like vowels. They travel. In fact, I prefer to imagine myself as someone who does away with consonants altogether. I want to exist as an *ooh*, an *ah*, even an *eww*.

In addition to being an ethnic wildcard, I've also become something of a sexual buffet. All you can eat. Like the Sunday breakfast specials at every chain diner off of I-94 from Paw Paw to Livonia. Oh, I've been with men and I've been with women. And I question which of those I am, if either one. Some days I feel that I am a cowboy—aloof, tough, grimy, and proud. I have a swagger. Other days I feel like a haunted young woman, one who is beset by visions and who hears the thin voices of the dead calling to her in her sleep; a woman who loses track of where she ends and others begin. Also, I envisage myself as being at once very old and very young, maybe because gender neutrality belongs to those early and late stages of living. Anyway, I never know who will be attracted to me, or to which aspect it is they'll be attracted. I just try to roll with it. You could say I'm a liquid asset in the economy of desire. Converted easily.

ANDRAGON

I have never met another person who is the way I am. For this reason, perhaps, I occasionally entertain somewhat eccentric delusions of grandeur. For example, a couple of months ago it occurred to me that I might actually be some sort of black hole. Once an unsuspecting person sleeps with me, I mused, their entire existence might: a) cease, or b) henceforth continue inside of me. I should test this hypothesis, I decided. So when my best friend from high school, Jacob, came over and spent the night, I came onto him, which I'd wanted to do for years anyway. (He is straight, but one day a couple years before we kissed for a moment while taking turns making out with the same girl, so I figured he might be the up for anything kind.) The two of us were on our fourth or fifth glass of dark rum and we were listening to Peetie Wheatstraw, a bluesman who sold his soul to the devil less famously than Robert Johnson, on the record player. It was about 3 a.m. As Jacob got comfortable on the couch and put his feet up on the table, I waddled over to him, using my knees to move across the carpet. I whispered, "Can I touch you?"

"No," he said immediately, like a reflex. He paused and added, "You're a stunning creature, but I can't."

I never turned the record player off that night. The blues finished and I listened to fuzz for three and a half weeks, until the machine finally died. Creature, I thought to myself. That's what I am.

I'm not at a loss for admirers. There are many in town. The bisexual shuttle bus driver made his feelings known months ago.

He could barely keep his eyes on the road. The goth cashier at Kroger also springs to mind. I see her fidgeting with the pewter ankh around her neck every time I come striding through those automatic sliding doors. And the gas station attendant on Main Street? He practically propositions me every time I get a fill-up. I think he's American, but he might be of Middle-Eastern or Israeli descent, I can't be sure. He's not awful looking, but there's something creepy about him. I first suspected he had a thing for me when his fingers lingered in mine as he gave me my change one evening last month. My suspicions were confirmed the next time I entered, when he made kissy faces at me and then asked if I wouldn't like to come by after hours. It's a twenty-four hour gas station so I'm not sure how that would have worked. As I was going out the door he said, "God, you're beautiful" rapidly and under his breath, as though it were a subliminal message or the result of a special type of Tourette's syndrome where you can't help but compliment people. I turned around. "You're so andragonous," he added. "I fucking love that."

Andragonous is what he called me, which is, it seems, a combination of *androgynous* and *dragon*, elaborating the notion that my gender, beyond not being distinguishable as either male or female, is perhaps not even human. I bid the clerk adieu, but the word stayed with me. Andragonous! The term describes a creature of mythic proportions, I thought to myself. A tragic beast, terrorizing the kingdom, waiting to be slain. Andragoness? Maybe it's part dragon and part princess.

ANDRAGON

I had nearly forgotten about both the clerk and word until last night. See, I went in to pay for my gas and to pick up a Rice Krispies Treat (my favorite) and the guy actually cornered me behind a wall of Wild Cherry Pepsi six packs. He grabbed my hand and guided it over the bulge in his pants. I have to confess that I momentarily considered giving him a hand job, speculating that I might be able to get a couple more free Rice Krispies Treats out of the deal.

"The first time I saw you, I didn't know if you were a man or a woman," the clerk confided. "I just knew I wanted you," he said with a lusty snarl. *If he doesn't know what I am, does he know what he is?* I asked myself. At that moment I wanted to split him in two, a man and a woman, and let them fight over me. I wanted to be the gleaming green andragon between them, to become their argument.

So I gave in. I led the gas station clerk to the far back aisle, my dragon's lair, the dark corner with the cappuccino machine. He pinned me hard against the display case of Hostess snack cakes, causing an avalanche of Twinkies. I reached for a shelf to steady myself, but I dislodged it, sending a medley of packaged snacks tumbling to the ground. "I'm still not sure what you are," the clerk gasped, unfazed by the mayhem. I didn't want to tell him. I wanted to spread my andragon wings and soar from gender to gender. We dropped to the floor and he kissed me. He wrapped his tongue around me like I was a foreign language. My head was nestled among many bags of Funyuns, which crinkled noisily

with our every movement. From then on we formed no words, only vowel sounds.

The clerk smelled of sweat, menthol cigarettes, and Doublemint gum. I breathed him in. Our bodies moved in sync, pounding against the chilly, grubby tiled floor. When our tempo slowed from largo to grave, I knew the two of us were entering into that impossible, parallel world known as *after hours*, where time unfurls and seconds become vast. The clerk grinded me, and my skull ground relentlessly against those Funyuns, destroying them. Refining them.

We were intertwined, trapped in each other. And in the icy glow of the drink cooler the clerk suddenly appeared to me to be turning the color of Christ in one of Giotto's *Crucifixion*s, a pale green. My vision had begun playing tricks on me. I watched his nostrils open as wide as eyes. Then, just before it was slipped back into my mouth, I saw the clerk's slender tongue extend almost all the way down to his Adam's apple. I squeezed my eyelids shut as I received it. As he exhaled, I inhaled. I began to notice that his breath was pungent, just a tinge rotten. This only made me hungrier for him. My ecstasy remained unbroken even as I heard the bells on the gas station door jingle, followed by the footsteps of somebody else heading toward us. I kept my eyes closed and held on tight to my clerk. I'll never leave, I vowed silently, never. I could feel him breathe fire down my neck.

ANDRAGON

CAT ANTIGONE

My friend Chavisa's cat was kidnapped and became a celebrity. When you're famous for being gone, the world is suddenly chattering about you, but no one is sure whether to use past or present tense. Chavisa discovered soon enough that her companion was being held in an undisclosed location, so that much was settled: he was alive. He had been assigned a new name, like a true brainwashed hostage. The cat's picture was in the papers, while his captor was unknown; this was to become a drama of visibility. Rescuing him would not be easy.

But let's back up, and also zoom forward. Chavisa imparted to me the whole story of the cat, from the day she met him, through the abduction, to the years that followed. We sat at her kitchen table as she puffed cigarette after cigarette. I remember the story well enough and I'll tell it to you now. If you'd like to imagine that she's telling the story herself, well go right ahead and picture her: like a character played by a young and plucky Shirley MacLaine, blades of orange hair on her head, laughing at high decibels. Crying once in a while, too, and who could blame her? The cat was dead now. She'd just buried him yesterday. His dander was still hanging in the air—I don't know if

you're allergic. Anyway, you'll be breathing a lot of secondhand smoke.

He was a Russian Blue. I got him the day I moved out of my grandparents' and into my own place in Saint Louis. I always say, "It was so horrible how these teenage boys threw this tiny kitty out of a moving car onto the highway, but luckily, it was in front of a lesbian coffee shop!" Ha! All these dykes ran out, stopped traffic, and scooped him off the road. I picked him up. He was covered in blood, his left ear had been torn off, and one of his bones was showing. But he started purring as soon as he was in my arms. I took him to the vet's and named him Oliver.

We developed our little ritual, right away. Did you ever see it? I would jingle my keys and he'd come scampering over to me. Almost like a dog. It was cute. Oh, was it cute.

A stunned look appeared on Chavisa's face and her eyes no longer peered outward. She was probably hit by the fact she'd never see her cat again, except in her mind. While she is taking a moment here, I'll mention that throughout her childhood Chavisa lived in a poverty-stricken village in Southern Illinois, alternating between a loving yet strict home with Baptist grandparents, and motels and other shaky arrangements with her homeless, schizophrenic mother. So a new existence, her adult life, was marked by the appearance of this cat. And she named him Oliver, like Dickens's scrappy orphan, born into misfortune. But little did Chavisa know that a new saga about class would come to surround Oliver the cat in both life and death.

CAT ANTIGONE

Two years later—no, four. Three? Three years later Oliver and I drove to New York and moved into the back of Tribes. I wanted to move to New York and had a friend who said, "I know a blind man named Steve Cannon who has a gallery and literary journal in New York. You can live with him and work for him."

Steve would always introduce me to the older artists, neighborhood Lower East Side people. "This is Chavisa, the best damn poet in New York City." Ha! Then he'd also say, "She plays the fuckin' trombone. She's the best fuckin' trombone player in New York City." I did play the trombone, but I wasn't very good. I wasn't trying to "make it" as a trombonist.

"And this is Oliver," I'd say when introducing him to everyone. "He's a lover but he's very into consent. So you have to let him know if you want him to rub up against you." That was true—he never rubbed against people who didn't want him to. He could sense that.

He could sense where I was too. Roommates in Saint Louis always told me he'd go to the door and wait for me several minutes before I arrived.

When I gave readings at Tribes, he would sit next to my feet. As soon as I finished, he could sense it. He would turn, and then I would turn, and we would walk out to the garden in the backyard, leading the crowd out to an after-party.

You know, Tribes became my world. The older artists—the "olds," I call them—were always arguing about art. Fiery arguments, which were sometimes lofty and sometimes petty. They

CAT ANTIGONE

would critique my poems, give me assignments, and scold me, saying "Chavisa, that's embarrassing!" if I didn't know some literary reference one of them made. I didn't go to college, but this was my education. Anyway, in the daytime I'd work at Tribes, reading newspapers and emails out loud to Steve. And, you know, telling him which part of the table his cigarettes were on . . . and when the matches he lit were still on fire. Oliver followed me everywhere and was always sitting at my feet.

So Oliver was Chavisa's shadow, and Chavisa was Steve's eyes.

The period she has been discussing here, by the way, predates my meeting her. I met her on the rooftop of the Delancey, when she and my friend Thain tried to drown each other in a fountain. Earlier in the evening I'd seen her win a performance-art gong show; she billed herself as a "humorless lesbian comic" and told jokes such as "What's the difference between my mother and George W. Bush? George W. Bush was born the son of the President of the United States of America, attended Yale University, and grew up to become President of the United States of America. My mother was born the daughter of an alcoholic factory worker, was beaten as a child, quit school when she was fifteen, and grew up to become an alcoholic who breeds pit bulls." I kept running into her in other clubs, and then read her first short-story collection, which contained many episodes of rural violence and suffering. These had the magical quality

CAT ANTIGONE

and weight of fables, but I learned some of them were thinly veiled autobiography. Back to Oliver:

One day I went out of town for the night. So Steve had someone else come and read to him. And this woman left the door ajar and Oliver ran out onto the street. Steve couldn't see this, of course. So when I came home the next day, Oliver was nowhere to be found. I started asking around the neighborhood. Someone told me Maria had picked him up. Maria was a crazy seventy-year-old in a leather jacket who taped stuffed animals to herself and wheeled around a shopping cart full of live animals!

People on the street told me Maria had taken Oliver to Kit-tyKind, the shelter up on Fourteenth Street. When I went up there and showed the receptionist a picture of Oliver, he recognized him right away.

"Oh! Gatsby," he said. "Such a lover. He was in and out real quick."

"Gatsby!?" I said.

"Oh yeah, the woman who took him named him 'Gatsby.'" Then he looked me up and down for a second, at my hair and my clothes. [Pink hair and anarcho-ragamuffin attire.] *"Hon, that cat is living with a lawyer now. I'm sure she makes a lot more money than you and she can give him a great life. She's spoiling him rotten," he said, and winked. I couldn't believe it.*

The receptionist was unaware he was speaking to someone who had just stubbornly read all 926 pages of Gertrude Stein's

The Making of Americans and who was known to break bottles over men's heads when they wouldn't stop coming on to her in dive bars. Chavisa is not one to take no for an answer.

"That's my cat and I want to know where he is," I said!

The receptionist finally went and got the boss, Marlene. Marlene is the same woman who would later be jailed for hoarding the rotting bodies of 200 cats in her own backyard! But at this moment she came trotting out of her office with her chin held high and said I'd have to prove my cat's shots were up-to-date before she'd tell me where he was. She obviously thought I was an irresponsible punk kid, and that I wouldn't have the documents. But Oliver's Saint Louis vet faxed the papers over right away. Well, the next day on the phone, Marlene sounded a lot more worried, like she knew she could get in trouble. But she wouldn't reveal the name of the lawyer who had Oliver. She just called her "Jane Doe." She explained that unfortunately, this lawyer had already bonded with "Gatsby"—it had only been a few days!—and she said that he was an engagement gift for Jane and her fiancée, and that Jane would be keeping him.

I was devastated. I went home to Tribes and sat in the garden with my notebook. I wrote a letter to Jane Doe, begging her to give me my cat back. I told her how I rescued him from the highway, everything. But in case she was going to keep him, I also outlined all his needs, his dietary restrictions. Like, he needed to be fed certain foods, because his breed is prone to these rare urinary-tract infections.

CAT ANTIGONE

The next day, I dropped off the letter to KittyKind, then went back to Tribes and started desperately scheming. My lover at the time was Razor. You know Razor? Oh, Razor was this nomadic trans man who was really tall. Like seven feet tall, if you measured from the bottom of his platforms to the top of his liberty spikes . . . Anyway, so I told Razor everything and he immediately told me to start posting my story on Craigslist. He was like, "I had a friend who had a problem once and then posted it on Craigslist, and things changed!"

I was willing to try anything, and Razor was willing to help. So we stayed up all night, posting the story of this injustice on every Craigslist site, like, in the world? The English-speaking world?

And it worked! So I was sleeping in the next day and got woken up by a phone call from the New York Post! They interviewed me and ran a story the following day. The headline was "TUG-O-TABBY" and the article was really sensational. It said, "Chavisa Woods is in a RACE AGAINST TIME to save her cat's life!" Ha!

OK, so this is when my benefactor comes in. I got another phone call from this guy who had read the article. This stately older gentleman named Philip Selden. "My dear, yoooou don't know who I am, but I know who yooooou are," he said. "And I want to help yoooou with your cat." He told me about all his other animal battles, and achievements. Like he funded a campaign to ban pigeon spikes in Central Park. And he'd once gotten a plane to land in the middle of the flight, because a kitten was on the loose in the luggage

CAT ANTIGONE

145

compartment. It was like: if you've got big animal drama, this is your guy!

So Philip Selden started firing off press releases that referred to Jane Doe as "The Wicked Witch of the Litter Box." He sent letters to KittyKind and Jane Doe's lawyer, talking about this army of protestors he had at the ready at all times. "But once I unleash them," he'd warn, "I simply can't control them, try as I might."

And he hired a lawyer for me. The legal battle took an entire year. We sued KittyKind for not revealing the identity of Jane Doe and we sued Jane Doe for custody of Oliver. Part of the reason it took so fucking long is that we had to challenge an 1894 NYC law specifying that once an animal is seized by an "authorized city agency," pet owners lose custody if they don't file a proper claim within forty-eight hours. There were more articles! "FUR FLIES IN LOST CAT SPAT" was the Daily News one. They called my battle a "claws célèbre" and had a photo of me. At the time I had a single, very long, pink dreadlock, which they oddly airbrushed out.

Then the Times ran an article discussing the ramifications of overturning this old law—like it might make people afraid to adopt pets, if the original owners could pop up and sue them, and yadda yadda. I'm quoted saying, "The fact that it's become a seminal case infuriates me, because it's taking much longer and I just want my cat back!" Which was true!

That all happened fast, but then the state Supreme Court Justice, what was her name? Uh . . . Marylin G. Diamond. Justice

Marylin G. Diamond scheduled a full trial, which wasn't slated to happen for a year. So I was hopeful about this trial, but couldn't bear being without Oliver all that time. Do you know? I felt like the wind had been knocked out of me. I cried myself to sleep every night. Every night. I went up to Hudson, New York, and stayed with a friend for a few months, just to get out of the city and try and pull myself together.

In the meantime, Philip Selden hired my friend Nikki to photograph his fluffy Persians in different poses and costumes after asking me, "Who took the fabulous portrait of Oliver that was run in the Post? Exquisite!" Well, Nikki usually photographed junkies and corpses, but shooting glamor shots of these pampered cats got her more money than she'd probably ever made off photography. Philip Selden also tried to convince me that I should 'write' a coffee table book filled with pictures of Oliver, and he offered to bankroll it. But I was just concerned with getting Oliver back at the moment—and, besides, I thought such a thing would make me look silly; I thanked him but explained that I was just beginning to gain respect among the downtown poetry community. "But my dear," he laughed, "no one respects them!"

Jane Doe agreed to settle. But not until the day before the trial! You know why she finally settled? Because her name would have been revealed. Well, she was so despised at this point, maligned in the press, she was probably afraid of public humiliation. Maybe she was afraid of Philip Selden's feral army of protestors! But it was strange: Oliver and I were all over these articles, with pictures

of our faces. We were everywhere. But Jane Doe stayed anonymous forever.

I never saw her and I never knew her real name.

I didn't even see Jane the day I got Oliver back. I picked Oliver up from my lawyer's office. Her lawyer had dropped him off. I remember, I got down on my knees and opened the door to the cat carrier. "Oliver, it's me." He stayed in there for a while. Then he stumbled out. He was skittish, turning this way and that.

He didn't seem to know who I was or what was going on.

Then I had an idea. I walked to the other side of the room, pulled out my keys, and jingled them. And he came running! I picked him up and held him.

That first time I held him, remember, on the side of the highway? He was stripped down the bone. Well, this time was a little different. This time I couldn't feel his bones. He was fat now.

Jane Doe hadn't fed him the right food and he had nearly doubled in size. When I took him to the vet's he was diagnosed with diabetes, which is what finally killed him.

She paused.

So in a way, that news article wasn't so sensational . . . It had been a race against time.

Chavisa started tearing up again. She got up from the table and started rooting around the kitchen for alcohol. There were no beers in the refrigerator, no wine on the table. She eventually seized a bottle of birthday cake–flavored vodka from a forgotten cupboard, leftover from some arts fundraiser she'd helped with.

CAT ANTIGONE

Chavisa and I drank it neat, out of tiny jars. The taste and after-taste of this elixir were vastly different, yet equally unpleasant. Each new sip provided relief, though, in the way a new injury seems to alleviate the pains of old ones. And the alcohol appeared to comfort and relax Chavisa as she related the last chapter of her story. This last episode was the most raw. Even as she reached the end, her story was still not finished.

Oliver lived another six years. That's something, isn't it? Six years? And he was happy—still himself, just slower. I had to give him insulin every day. Finally, his kidneys just—

Of course I wanted to bury him at Tribes. I haven't worked there in a few years, and haven't lived there for more than a few years, but I still go read to Steve every couple weeks, and it's still— it's home. Oliver had so many happy times there, in the yard especially.

When I asked Steve, he told me it was fine. "Oh yeah, there's a dog buried back there already," he said. "Probably some other dead bodies back there, too. I mean, this is the Lower East Side and shit. Some dead fuckin' bodies, hehe. Might not even be room back there, hehe."

Two days ago I held Oliver in my arms for the last time. I wrapped his body in red velvet. I dug a grave back behind the bushes, at the edge of the lawn. I laid him gently inside, covered the grave, and marked it with a stone.

But then yesterday Steve called me. "These motherfuckers from downstairs got ahold of the police," he said. "And a fuckin' lawyer,

CAT ANTIGONE

and the landlord." This couple who just moved in downstairs, from the suburbs, saw me out there, and they're complaining that it's unsanitary to have a cat buried in the yard. They're saying they're afraid it's going to make their daughter sick. I mean, what? He's four feet in the GROUND.

Steve should have never sold the building. The landlord, the lady he sold it to, is trying to get him out, and has been for years now. I forget that. And of course I feel like Steve will somehow manage to stay in that building forever . . . If I didn't, I wouldn't have buried Oliver there. I mean, Steve always gets away with whatever he needs to get away with. You know? Like he managed to sell that same David Hammons painting to multiple people, and yet also keep it for himself.

But this landlord, she's looking for any excuse. I called her yesterday and tried to smooth things over.

"Why were you trespassing on my property?" she asked.

"Steve gave me permission," I assured her. Then she turned the tables.

"His permission to bury the cat?" she asked. "I see, so he's still acting as though he is the landlord . . ."

"No," I rushed to explain . . . I didn't know what to say so I blurted out the weirdest claim. "No," I told her. "Steve gave me permission to hang out in the back yard . . . I just assumed I could bury the cat back there too." Ha! That sounds crazy, right? Like I just happened to be lugging a dead cat around and decided to bury it, out of convenience, as I lounged on my friend's patio?

CAT ANTIGONE

Chavisa took a gulp of the birthday-cake vodka, lit another cigarette without thinking, and fixed her eyes on a blank stretch of kitchen table.

Anyway, neither Steve nor I thought it was going to be any kind of problem. I mean, Steve is from New Orleans. And I'm from the Midwest, from the sticks—we bury pets! Don't you do that where you're from? Bury pets in backyards? I mean, right?

So this morning I get an email, a legal demand.

It says the "body must be exhumed" and the area "must be sanitized." I'm afraid they're going to kick Steve out, take Oliver's body and do god knows what with it.

So now . . .

I have to—

"I'll do it," I said, from across the table, swigging my own birthday-cake vodka, fanning the smoke away from my face. "I'll do it."

It's not that the thought of digging up my friend's dead cat filled me with delight, only that the thought of her having to do it herself was troubling. It wouldn't be nearly as harrowing for me because, while I'd always liked Oliver well enough, my allergies had stood in the way of our forming too deep a bond, and also I like to jump on any opportunity where I can come off as tough and valiant and here was one just falling into my lap.

Chavisa and I drank a glass of water each, to wash away the liquor taste. It was already late afternoon. There were still a couple hours of light. We locked the apartment and set out for

Tribes, carrying a cardboard box and two garden shovels on the J train.

"Trespassing. Bullshit. Trespassing?" said Steve Cannon, seething on his couch like a deposed king. Chavisa and I had joined him in the living room with our box, still empty, on another chair. "Well, the other day one of those motherfuckers from downstairs needed to walk through my place to get out back because he'd locked his keys indoors. So maybe he was trespassing in *my* house. Think I should call the police on them? Or how about I get a buncha junkies from Tompkins Park, like a few hundred, and have a party over here? Buncha fuckin' dope fiends? Haha. Think they'd like that? Those fuckin' yuppies? That'd scare the shit out of 'em!"

"I'm glad Steve is angry on my behalf," Chavisa whispered to me, grinning, as we got up and headed toward the back door. "It makes me feel protected."

Our gruesome errand had already taken on some sense of mythic weight, I thought, as Chavisa and I walked out back into the summer night, leaving Steve inside to plan his junkie revenge festival. Oliver's story, at first Dickensian, with a little Fitzgerald interlude of excess, was now pushing toward the Greek. It was a drama concerning territory, burial and the honor of the dead. Like a great, feisty heroine, Chavisa would have to perform this dreadful exhumation, at dusk now, to protect the body of her faithful companion. And Steve Cannon wasn't exactly Tiresias, the blind seer who is full of cautionary visions, but he was a po-

tential source of discomfiting truths (the suburban transplants vs. band of junkies might bring about some of those . . .). Maybe this is just how I wanted to see everything. Perhaps this episode was more like one of Chavisa's own stories. Her work is filled with characters doing and watching things that neither they nor the reader are fully prepared for. Lamps are smashed over little girls' heads; there are night rides to blow up buildings, acts of self-defense that bring about grave consequence, and people falling in love with animals. Digging up the corpse of a beloved pet could fit quite neatly into this oeuvre. As I mentioned before, Chavisa conveniently plucked some brutal acts from scenes she witnessed in her own childhood—the world around her mother was rough and dark in ways many people can't imagine. And she had to contend not only with real danger, but with her mother's visions of figures and conditions that were not real—storms outside on sunny days, alien abductions, missives from dead prophets. Many visions were threatening, but there was the rare miracle too. I have wondered if those visions, this *invisible other world*—more fluid, unruly, and close at hand than the heaven and hell invoked by her Christian grandparents—created a particular element of magical realism in Chavisa's work that allows people to fly away on a sofa, or a war to take place atop a person's head. This is what I was thinking as we walked out to the edge of the yard that evening.

There was little magic and much realism in the task before us. We located the rock that marked Oliver's place, in this little cor-

ner of the natural world, which was still permeated by sounds of the city. I heard sirens and distant shouting. I knelt down to the ground and started digging.

Across the dark lawn, a curtain parted on the window of the back door, and the couple's two scowling faces appeared. Half lit, a pair of Jane Does in the doorway. They may have wanted to monitor us, to be certain we were actually removing the body and not simply pretending (a prank we also entertained.) Or maybe they wanted to see if we were properly "sanitizing the area." How one sterilizes dirt in downtown Manhattan I do not know. Might we squirt some Purell at the ground?

I dug down a couple of feet. First I found a smattering of rose petals in the soil. Then red velvet began to show. Chavisa stood several feet away and averted her eyes as I pulled Oliver's stiffened body out of the ground. The dirt showered off of him. I placed the body inside the box, closed the flaps, and set it to the side of a shrub.

"OK," I said.

"OK?"

"Yep, all done," I replied, signaling to Chavisa that it was now safe to look. It wasn't like she was pretending this whole thing wasn't happening, but no image can be willfully erased from one's memory and this was a sight she should be spared. She came over and together we scooped soil back into the hole and patted it down.

CAT ANTIGONE

We went out to Avenue B to hail a taxi. One passed us by, even though it had its light on. "I'll report you!" I snarled, chasing after it. The box, a bit heavier now, was still in my arms as I galloped down the street. Did the driver somehow intuit that we had a dead cat in tow? A few minutes later we got a cab to take us back to Brooklyn. "It's OK?" Chavisa asked, unrolling her window and lighting a cigarette as the driver flicked his out. He nodded. "Thanks, hon." She patted the box and winked at me.

Once we were back in Brooklyn we dug a second hole, this time in the back yard to Chavisa's current apartment. I lowered Oliver down and covered him with a layer of dirt. We buried him again.

Here's the strange thing. I know the first grave was in one place, and the second in another. I know they were in two separate boroughs, and I vividly remember our journey from one location to the other. Yet for some reason, in my mind, we were in only one place that night. It was all one garden and we were so close to the ground, working along the border of the seen and the unseen.

SOUNDS AND UNSOUNDS OF THE CITY

I live under the J train and I always brag about it.

What neighborhood do you live in? they ask. *Under the J train,* I say.

I know those elevated train tracks cast a shadow that stretches miles down Broadway. But for me, that shadow is my neighborhood.

Once when an earthquake reached New York, I didn't even realize it because the train went by at the exact same time. Everything in my living room was trembling and a matryoshka doll even tumbled off the top of my bookshelf and spilled its smaller selves across the floor, but I just thought, "Well, well, that express train is barreling by with extra vigor today." Even when the trains skip all the stops in my area, stranding me, they still pass over my head. If the J train were to derail it would derail into my living room—and I hope someday it does.

Isn't it noisy? people often ask.

Yes is the answer. In the living room in springtime, when the windows are open, I and a friend have to stop our conversation as the train goes by. We just have to sit there and look at each other, as though the train has put us both on hold. I like that, the way it pauses conversations.

The other noises around my apartment are worse. There's a police station nearby and there are always sirens going off. So many sirens that I think some cops are turning them on just to zoom around and look all tough and run red lights. Also there are traffic jams in front of my place all the time and people honk at each other, sometimes laying on a horn for a full minute. I often run to the refrigerator and take out a couple eggs, then charge back to the window and wrestle it open to take aim at a honker. Strangely, traffic always starts moving at this very moment. Some nights there's a car parked out front with a noisy car alarm, which is activated every time the train passes. I've never egged those cars, though they deserve it. But I leave threatening notes, like parking tickets, under the windshield wipers, and that seems to scare them away. "Don't come back or we'll destroy you," one might say. Who's we? I don't know. My handwriting is barely legible anyway, but it looks like it belongs to someone who is unsound and over the edge and honestly, the medium is the message.

There are many random noises. Nuisance serenades. Once at 3 a.m. a man came and stood in front of my building playing mariachi music on a boom box and striking a cowbell on the beat

for about forty minutes. He wasn't playing for tips, he was playing for pleasure. He was doing a "happening." Eventually he finished his set, packed up, and disappeared back into the night.

I never cherished the privilege of having the Army recruiting center under my apartment when it was there, but I grew to miss those quiet soldiers, sitting at their empty desk, once the storefront church set up shop. A Brazilian subletter I had said, "Those churches are all over poor neighborhoods in Brazil." The pulpit was underneath my bed. The preacher sang Christian karaoke on a PA system from hell. He was wildly out of tune. I was glad it was in Spanish, because I understood less.

This church was not the sort that had service only on Sunday. This church held services many times a day. Sometimes there were only one or two people in the congregation—I'd glance in as I left my apartment. Still, the preacher was screaming into his microphone. You could tell it was fire and brimstone stuff just from the cadence and volume of his delivery. He growled and hollered and got all worked up into a religious fervor, even though the chintzy MIDI sounds of his backing tracks were placid as can be, like Muzak in a department store. Sometimes he drew a big crowd. Like the day I saw twenty or thirty people in there, and they had one giant red blanket over their heads. I have no idea why. It must have been something he made them do because there he was, standing before them, singing his MIDI Christian tracks as though delivering a hostile lullaby to a big red blob.

The preacher also sang and preached in the middle of the night, at 4 a.m., 5 a.m. Maybe he was just rehearsing, because there was often no one in the congregation (I've looked), or maybe he was hoping to lure them in. Maybe the Midnight Cowbell would join him one day. The preacher's compulsive sermons made it hard for me to sleep, or think. One day I tried to watch a movie. I turned the volume up all the way, but I couldn't understand anything because the noise from downstairs was too loud. The sermon was all around me. It didn't even feel like it was coming from another floor. I was at once in my apartment and somehow also inside a church, hounded day and night by some invisible, two-bit Savonarola.

Now, I am no light sleeper. I was able, for example, to sleep through every class, every single day of high school, even after my teachers banded together and all made me sit in the front row and poked at me with yardsticks. I am also no yuppie who is whining about the buzz of urbanity that wafts through his windows, nor am I trying to remold the neighborhood in the image of an overregulated suburb in Middle America, where sound has forgotten how to travel. But after several sleepless weeks I did make mention of the noise to my landlord. I am under the impression that he is the only reasonable and benevolent landlord in all of New York City and he came out and listened to the church from across the street for a few minutes and then crossed his arms, nodded his head, and declared, "Yes, we will sound-proof the church." Thankfully, this had an effect—it slightly

dampened the noise so that I could *almost* hear a movie. But it wasn't enough to let me reclaim my famous talent for sleep during stretches when the sermons raged on.

One morning the preacher started at dawn and kept at it until noon. I slept in fits and starts and my cherub-faced boyfriend was awake for most of it. He admitted to being fluent in several languages, and I'd watched him speak a few others too, in tricky situations and in his sleep, and Spanish was easy for him. "What's he going on about today?" I asked, petting him as I finally surrendered to the brutal morning.

"Oh, he's condemning homosexuality," my boyfriend smiled.

Another night my boyfriend wasn't over, but my friend Thain was. He is a scrawny and enterprising white South African witch-punk. He reads tarot cards, performs cleansing rituals, and once in a while is available as a rent-boy too. He has been trying to convince me to let him do business in my apartment on days when I'm out.

"I'll give you a cut," he said.

"OK. But what if your clients see that it's my place?" I asked worriedly. I meant that there might be bills with my name on them lying around. "I don't want anyone to recognize that it's mine."

"Oh, is that so? And where are they going to recognize it from, pray tell?" he asked haughtily, rolling his eyes and glancing around my living room, which was furnished only with a floral corner sectional (orphaned from its sofa and coming apart at the

seams), a would-be table with seahorses for legs but no tabletop, a rickety office chair—all items from the street. I had decorated with more gutter treasures such as a ruinous Corinthian column and two weathered porcelain Virgin Marys. "Where are they going to recognize it from?" he repeated. "*Down and Out BoHomo Magazine?*"

We spent the evening talking and listening to music. We put on old records of Black Sabbath, Exuma, Screamin' Jay Hawkins (my lord and savior,) the Birthday Party, and our favorite album, *Street Walking Blues*, a compilation of songs from the twenties and thirties mostly about hustling and pimps. It features Ma Rainey, Ethel Waters, some great Cab Calloway songs like "Saint James Infirmary" and "Nobody's Sweetheart" and also the classic Lucille Bogan number "Shave 'Em Dry" which contains the gem of a line "your balls hang down like a big bell clapper and your dick stands up like a steeple. Your goddamn asshole stands open like a church door and crabs walks in like people!" after which the singer laughs uncontrollably and whoops. The height of twentieth-century verse. I find a song like that far superior to Cole Porter's mawkish "Love for Sale," and I imagine Thain agrees.

Thain prefers to take his whiskey straight from the bottle. And since all my glasses and mugs were dirty I was having mine in a saucepan when we both nodded off in the living room, only to be awakened a couple of hours later by a sermon erupting from below. Thain opened his bloodshot eyes, looking rattled.

I bet I didn't look like *Sleeping Cupid*, either, boozy and slouched as I was in my old office chair. The karaoke track rose up through the floor, bringing to mind a pale and off-kilter version of some Whitney Houston song from the early nineties, with that cheap sense of aspiration, those misty synths that I can't believe didn't sound dated-on-arrival. Good old Whitney of course was a supernatural voice who rose above the unfortunate production fads of her time, unlike the preacher's voice, raging out now like a despot in a midnight choir. I looked at the clock; it was 5 a.m.

"I'm gonna stare that preacher down," said Thain. He was standing up, looking like a movie hero you thought was dead, emerging from wreckage, ready for the final battle. He poured himself a glass of some old cooking wine and swigged it down.

"Oh," I muttered. "Be careful." I didn't know what sort of confrontation Thain had in mind and didn't know if it was the best idea, but he's not easily persuaded, so I just staggered into the bedroom, tore off my clothes, and slid under the covers as he marched downstairs to wage war. In spite of the preacher's noises, I was able to fall back asleep. But shortly thereafter I was awakened by the dinging of my phone. Thain was texting—dispatches from the battlefield. *I will not say a word. I will only cross my arms and summon every devil I know.* That's nice, honey. I let the phone fall back out of my hand, not bothering to reply. A few minutes later the phone dinged again. *Dark 1s are on their way . . . Preacher man has been blathering about god knows what.*

People coming in. He's singing again. Thain continued to text a play-by-play of the preacher's actions, which I clearly didn't need, since I was lying just feet above his head and was kept all too up-to-date on what he was doing. *Don't worry, my dear friend,* came another text, *I will avenge you. You shall sleep again.* For all his chivalry, he apparently didn't consider that he might be the current culprit, waking me up with his stream-of-consciousness reporting on this odd mission of his, which was, as far as I could tell, to "sit menacingly" in the congregation.

6:39 a.m. *Congregation is scared. 1 by 1 they have risen from their seats and moved 2 the front.*

6:43 a.m. *They are cowering around him. They're like "Daddy, make that scary person go away." The demons are swirling inside me and I am letting them gaze out through my eyes.*

6:45 a.m. *Oh I must be quite a fright!*

6:50 a.m. *Well I have done it. I have held a presence of foreboding.*

At some point I drifted off, but I woke up around 9 a.m. to the congregation of non-angels lifting their voices, but not high enough to reach the right pitch. In any case, it appeared that they had overcome Thain's flock of devils and I was sure he had tot-

tered off, taking his menace to the streets like Melmoth the Wanderer before tucking himself into bed back at his place. The preacher's voice came in disharmoniously and shook my box spring.

I leapt up naked, wrapped my twisted sheet around myself, grabbed my keys, and went down the stairs. I stepped onto the sidewalk barefoot, pushed open the church door. "People are trying to sleep!" I yelped, masquerading as the representative of some community of the slumberless, rather than admitting to being a simple individual with a biological need for rest. Wearing bedding instead of clothes may have been a tip-off that I had personal stake in the matter. Even though the sheet was slippery and I may also have been committing some sex offense, members of the congregation turned and smiled at me. I was not holding a presence of foreboding.

As I closed the door, I caught a glimpse of the preacher, who fired me a strange grin.

When I returned home later that night, after a day of work, I entered a dark apartment. I flipped the light switch but nothing happened. Every appliance was off and the digital clock on the stove was black. I called my benevolent landlord.

"I would come over but I am in Delaware," he said. "The switches are in the basement of the church. Is anyone down there?" But for once, I discovered, no one *was* down there. For once the preacher would not arrive until noon the next day. Had he turned off my lights? I spent one night in complete darkness

and without the sounds of his voice. Perhaps Thain's banishing spell had worked after all?

When one sense is cut off the others are heightened, which is why certain people close their eyes to French kiss or take the first bite of a rich dessert. In this case, in the absence of light or the preacher's voice, my hearing became hypersensitive. I heard the trains coming from far away and the soft pounding and crack-lings of the radiator and other sounds belonging to it, which re-sembled the dripping of a sewer. I also heard sounds through walls that I couldn't decipher. Some distant sex. And a strange talking that was just out of reach. It reminded me of certain birds that learn English but mostly sit on your shoulder muttering rap-idly, sotto voce in moss-covered tones, so the words they utter are kept on the verge of intelligibility. For one night, here I was in my bed, leaning in to the sounds around me. I didn't miss the preacher or the power.

SHEILA

My voice teacher and philosophical guru, Sheila, answers the door in stretchy black dance pants, a fuzzy white sweater, and turquoise flip flops that have plastic jewels on the strap between the toes. "I took the libertay of pawrin' you a drink!" She declares, handing me a tall glass of beer. "We're gonna git happy from the hops!"

"We can drink first, then sing, then drink some more!" she says, leading me past the piano, to the sitting area in back of her railroad apartment. The room is spare, with shining, immaculate hardwood floors.

"Do you want the Chrysler Building or the Empire State?" she asks. Each of the two chairs in the living room has its own view.

"Empire State," I say.

"Oh good. 'cause I was really looking forward to the Chrysler." If I had chosen the Chrysler, Sheila would have been looking forward to seeing the Empire State. She has a knack not only for accepting, but celebrating, what is happening. Our visits are the high point of my week, and have been for three years now.

We sit for hours, ritualistically and sensuously sipping coffee, wine, and beer—measured acts of decadence—and talking. We perform ballets of the ordinary. Seeing her centers me. She once remarked, "Joe, you are one of the few New Yorkers I know who is both successful and happy." And I, not having considered myself to be either, suddenly believed myself to be both.

At fifty-five, Sheila has recently taken a nine-to-five for the first time in her life—in Birmingham she was able to maintain a full voice studio, which has proven difficult in New York, and the students she does keep she charitably undercharges—so nowadays we often commiserate by complaining about our jobs together. Out of the windows of her apartment we can see the neighborhood buildings, which are smaller and more quaint than the Manhattan landmarks. Greenpoint looks like a small European town, with a metropolis looming behind it, beyond the East River. Directly across the street is a four-story hotel. The five black-lettered tiles above the door spell *HOTEL*.

"Oh look out in front of Hotel. See that man? They call him Elvis. He's the one who's proposed to me three times. Can you imagine if I married him? He always hangs out there with that cripple. He's a good dresser, which is more than I can say for most of my boyfriends. I think he must have his clothes dry-cleaned. I know for a fact that Hotel *is* a flop house. It was on the front page of the *New York Times*! It's *famous*." When the room gets cold Sheila pulls a black fur collar from the back of her chair

and puts it around her neck. "So I briefly considered having three boyfriends all by the name of David . . . that way, when my phone rings I could pick it up and say 'David?' with absolutely no chance of calling one boyfriend by another one's name. I thought better of it though."

Sheila was recently the star of my birthday party. "I've discovered the secret to New York rent!" she announced, raising her glass to the cheering handful of twenty-somethings gathering around her. "Don't pay it!" The guests roared.

My friend John Moran has taken to calling Sheila "the guru." This is really praise from Caesar since John himself is a tortured genius of the old school whose only previous mentors are Philip Glass and a formidable cult leader with face tattoos named Storm Alligator. Sheila and I went to see John perform once and he seemed like he was losing his mind—stumbling around the stage, spouting non sequiturs, and laughing like a stoned teenager. When he did the exact same thing again, everyone realized he was actually lip-syncing to a recording of his own voice with great precision. "Now, I would consider that *cutting edge,* even in this day and age," remarked Sheila afterwards. John is often tormented by his classic artist's temperament, but he lights up like a kid the minute he sees Sheila—even the stormiest, most nihilistic young men I pal around with become sunny and silly in her presence.

"God, how many have we smoked, Sheila?" I ask, looking

down at the pile of butts in the orange squeezer we have converted into an ashtray.

"Doesn't matter," she fires back dismissively. "And if it's your *voice* you're worried about, lemme tell you this: It's actually good for your voice. How many times must I repeat this?"

"I know . . . I'm a bass. Smoking and drinking will help me . . ."

"That's absolutely correct. You know, Joe, not many people have low voices anymore. Our culture now lacks the depth needed to create those voices. But smoking helps." She draws another Parliament to her lips, strikes a match, and lights it, blowing smoke out toward Hotel. "You know a girl stopped me on the street yesterday and asked me if I lived in 3D. I said I did and she told me that her boyfriend used to live here. She's a very pretty girl—sandy hair. Twenties. Maybe early thirties. Well, she said her boyfriend overdosed. In *this* apartment. She asked if she could come up—and try to *talk* to him." She flashes a look of seriousness that quickly dissipates. "So I let her. She just sat in the living room a while. She said he's . . . still here." Sheila traces the edges of the ceiling with her eyes and raises her voice, "It's fine for you to be here! I don't mind. Just so long as you don't *make yourself known.*"

She chuckles and looks back at me. "Oh Joe, you look so much like Stephen with that cigarette between your lips. Y'all both have those dark features," she says, gesturing toward a

picture of her son. "Y'all could be brothers . . . Of course your and my relationship is an improvement on the mother–son dynamic." She turns her attention to the neighboring photograph, an old one of herself. "You know I never looked like that," she says, pointing at it. "My hair was never *that* dark. My mother wanted it to be. That was her color, so she had it done that way in the photograph. It's actually quite eerie. And you know, this was in her house," she says, gesturing to an oval antique mirror that hangs above the photographs. "My magic mirror that showed me the alternate reality—which I *preferred*. I would sit up on the back of the couch for hours looking into it. Not at myself, but at the world inside the mirror. One day my face went crashing into it and I had to be taken to the hospital. But, Joe—the mirror didn't break."

She looks back at me, beyond me somehow, as though I were the mirror. "Oh, Joe, you're so perceptive—I know you know something's wrong. You're not going to be very happy with me," she says softly, then bites her lips. "During a period of temporary insanity, I took out a loan and bought a house back in Virginia. I just can't *do* New York anymore."

She is right. I am not happy. In attempts to avoid Sheila's unwelcome news, I listen to other sounds around us. My ear detaches and goes flapping over to the window. It hears a baby cry through the wall. It hears a hulking man outside of Hotel say, "I gotta put on my gloves to go beat up a AIDS patient."

SHEILA

"I'm not gonna miss the neighbors," Sheila whispers. "Joe, I just feel like I should go back and be with my family. My sister and her husband. Every morning I get on the wretched subway train. I see a couple women just like me—there aren't many of us so we're easy to spot. Middle aged, frumpy, kinda overweight. At eight in the morning! I want to grab onto the sleeves of their blouses and look them in the eyes and say *What do we think we're doing*? Oh Joe, let's talk about something else."

"Do you want a glass of water?" I ask. I walk to the kitchen for a glass of water. When I return I notice them. Black marks all over the hardwood floor. They are circular and nervous, frenzied. Like a whirling dervish in tuxedo shoes has been in.

"Sheila, did I make these marks?"

"Oh my god. You must have. That's OK. I can clean them up."

But they are everywhere. In every corner. Even under her chair. Places I've never walked in the room. There are small, frightened marks, and sweeping violent marks. Both of us see the extent of the marks.

"*He* made them," Sheila says gravely, surveying the room, then letting her gaze settle back on me. I understand that she is referring to the heroin addict who died here. "Or *maybe*," she says, pausing like some literary detective, about to announce a theory, "you and he made them together."

Feeling a chill, I consider the idea of being able to draw with

SHEILA

171

my eyes. As if every place I looked throughout the room as Sheila told me her news, I had vandalized. This could be like a mutant power, a magic ability that surfaces first in a time of loss or rage and that with time and experimentation can be harnessed, honed, and commanded. Or perhaps these gestures on the floor were, as Sheila suggested, a spectral graffiti, the collaboration between myself and the ghost of another young person. Was he channeling his dismay through mine?

"This will not end our night." Sheila proclaims with a great sense of resolve, already up and marching to the kitchen. She comes back with two bottles—the big kind—of white wine. "We need to have a party," she says.

We open both bottles and start drinking, determinedly. Soon enough, effort disappears—the wine is pouring into our bodies, as naturally and inevitably as the Mississippi into the Gulf of Mexico. We drink until the room seems to buzz and hum, until the air feels alive, until the shadows in the room have grown into thickets, filled with inebriating night bugs that softly chirp to us.

Finally, we sing. Sheila sits down at the piano. She begins to play "Vecchia zimarra" from Puccini's *La Boheme*. It's the aria that Colline, the philosopher of the bunch, sings to his coat, which he is selling in order to buy medicine for his ailing friend Mimi. This takes place some time after the tragedy has taken its inevitable grim turn and the frivolity and youthful hijinks of Acts I and II are long gone.

SHEILA

"Here, Joe, you can hold this magenta jacket I got on Mese-role Avenue," she says, holding it out to me with her right hand while continuing to play with her left. "I know it's fetching be-yond belief, but just pretend it's ragged and masculine-looking. Acting."

Vecchia zimarra, senti, io resto al pian, tu ascendi il
* sacro monte or devi.*
Old coat, listen: I'll stay behind, you'll go on to
 greater heights.

Le mie grazie ricevi.
I give you my thanks.

Mai non curvasti il logoro dorso ai ricchi ed ai
* potenti.*
You never bowed your shabby back to the rich and
 powerful.

Passar nelle tue tasche come in antri tranquilli
* filosofi e poeti.*
You held poets and philosophers in your warm
 pockets.

I address the words straight to Sheila's sheer jacket, holding it and shaking it intently, as though the coat were in denial and I was demanding it reckon with the truth.

SHEILA

Ora che i giorni lieti fuggir, ti dico: addio, fedele amico
mio. Addio, addio.

Now those happy days are gone. Goodbye, faithful
old friend. Goodbye.

"Now Joe . . ." Sheila plays the last hushed funereal refrain, turning toward me. "The character is not *just* sayin' goodbah to a coat! He's sayin' goodbah to a life."

UNTITLED ARIA
(GPS SONG)

I

I've had many names!
Some of my friends used to call me "Spooky"—haha!
And I had a Love
Who called me some nicknames
(In a foreign accent)

And my Love and I
We spoke in baby talk a lot
The ultimate language of love?
The atrophied language of love?
Haha!

My Loooooove
Called me many names
Such as:

 Baby Animal
 Little Baby Animal

Big Baby Animal
Black Chicken
Bird Fallen from Its Nest

And I loved them all!
Even Baby Potato
Although it evoked something lumpy and sexless
I said yes. I said, "Yes! I *am* Baby Potato."

I I

My Love and I went bicoastal
So I was out in Hollywood
I knew something was wrong when my Love
Stopped calling me by these names

"Look it's me, Baby Potato," I said . . . "Still here, still lumpy!"

Nothing.

I I I

si dʊ mi mi si də rɪŋ ɖa ma ba
I sneaked around and looked at my Love's phone

UNTITLED ARIA (GPS SONG)

mi si də spɛlz ta d̜a wu poʊ

I found texts to someone else

wu poʊ bi ˈzibrəba

Someone called "Baby Zebra"

oʊ bi tʌnzʌ də spɛlz

There were so many texts

ɪn də hu seɪ

And they were in another language

an mi snæp ðɛm, an tæp d̜a spɛlz ɪn ˈgugəl trænˈzleɪt

So I had to take pictures and type them into Google Translate

"God is a bicycle, ride slow"

noʊn nu mi noʊ

Nothing made any sense!

umə doʊs bi pæl

My Love assured me the zebra was just a friend

UNTITLED ARIA (GPS SONG)

vʌt ˈtoʊtəl stuf bi sɪr

Still, things got bad—we had nothing to talk about

mi ta weɪ mi

I had to leave

ma ba wil mi ta flaɪ mi ʤi-pi-ɛs bi weɪk

As my Love drove me to the airport, the GPS was on

ma ba noʊ ðə rut vʌt tæpt də plæn pɛr də fu

My Love knew the way, but had entered the address to a later
 appointment

sɔŋ seɪ ta raʊnd də weɪ

So the voice kept telling us to turn around

Recalculating Recalculating

ma mi ba proʊʧ də hoʊm bat seɪ

As we neared the terminal the voice instructed:

raʊnt də ɛm weɪ

Turn on M street!

UNTITLED ARIA (GPS SONG)

raʊnt də ɛn weɪ
Turn on N street!

raʊnt də oʊ weɪ
Turn on O street!

ˈtoʊdəl də spɛlz
Every letter of the alphabet!

sis ɛm mi plɔr
"Can we pause that?" I asked

noʊ seɪ ma ba
"No," said my Love

də stoʊnz bi ɛndə də stoʊnz ɖa ma mi ba
These were our last moments after five years together

ma ba seɪ ɛntə də ɛn də wʌ
My Love said a quick goodbye on the sidewalk

vʌt ʤi-pi-ɛs sɔŋz bi sɔŋ
The GPS sounded strangely more full of desire

iˈplɔr meɪk ə ju tɜrn
Its plea emanated from the car window: *Make a U turn*

UNTITLED ARIA (GPS SONG)

ma ba bi weɪ
My Love was already somewhere else

mi də fɜr də flaɪ
I, the animal, the black chicken

seɪ də riəl
Tell some truth

vʌt mi sɔŋ seɪ
But I speak nonsense

ɪn də hudi spɛlz
Even now, I sing to you in an extreme baby talk

ɪn də hudi spɛlz, də hu bi nɔn
A shadow language, which does not exist

DAY OF THE DEAD

"I love the smell of scalp," Aunt Carol murmured through a heavy inhalation, her glossy mulberry nails burrowing beneath my hair. The rest of the family, seated around the Thanksgiving table, had watched in silence as she stopped to massage me from behind. Melanie and Angie, Carol's blonde daughters, found their mother's behavior increasingly inappropriate the longer it continued. The two became wide-eyed and tightened their lips, on the verge of explosive nervous laughter. My parents raised their eyebrows.

"Sit down, Mom," commanded Angie in a voice surprisingly raspy for an eighteen year old.

"Yeah, you're acting . . . funny!" commented Melanie, grinning. Three years older, and more wholesome than her sister, she got a kick out of watching family "scandals." At once unnerved and delighted, she pointed out the strangeness of her mother's behavior in order to downplay it. I myself did not mind. I had always enjoyed Carol's sensuous touch. Her sharp nails, the fluid, circular motion of her slender fingers. I concealed the intensity of my pleasure, forming a mild, benign smile.

That was nearly a year ago, the last time I saw Aunt Carol. It is now difficult for me to confront what will be her final dramatic action: death, by brain aneurysm. Melanie found Carol passed out, her body haphazardly draped across the bed. There were midnight phone calls, a three-day coma. Last night the family convened and decided to remove life support.

I stand in the midday light, which shines scantly through the windows of the Brooklyn apartment I moved into only months ago. Daylight comes in flickers, passing through gaps between cars of the elevated train that rattles past my window. I have agreed to sing "Ave Maria" at the funeral and must board a plane to Michigan in several hours. I sing at every family funeral because my voice is low and rumbling. I'm grateful to have been given this function; it is a comfort to draw out the feelings of others, rather than to be left alone with my own. I imagine myself as the shadow version of a wedding singer: I am a funeral singer poised like a weathervane before the crowd, waiting to tremble with its grief.

Standing outside the bathroom, I gaze through the doorway, into the mirror above the sink. Whenever I grieve, I watch myself and my surroundings, so for me this watching is part of grief. Maybe this fanatical self-observation protects me from feeling too much, or maybe I believe, wildly, that every loss will be balanced by some equal revelation of equal weight. And I am standing on the lookout. Right now I think, quietly, "I look good when I cry." My tears have clouded my vision so that I can't dis-

cern the crow's feet that stem from the corners of my eyes, which I feel are embarrassingly distinct for a twenty-two-year-old boy. Even on the occasions when I allow myself to see the creases of my face, my eyes dart jerkily over them—the way they do when I take notice of some former, anonymous sex partner on the morning train. Right now my reflection is a sublime blur.

The splatters of toothpaste on the mirror are really getting to me. Without thinking about it, I shuffle over, wipe the tears from my cheeks onto my hands, and begin to scrub at the spots with my fingers. This gesture only smears the toothpaste around and makes an awful squeak, a metallic whimpering. Sounds such as this are a musical theme in my life-soundtrack: the quick and furious scratching of my scalp, frenzied, like a dog's; the erratic movement of my hand over my face—as though I were drunkenly trying to sand a board; anxious little puffs of air that fire out of my nose; and a peculiar, barely audible high-pitched gulping sound that I make in the back of my throat. I am a nervous person. I turn on the faucet and try to splash water up to the mirror to dissolve the smear. Puddles litter the tile floor. I brush a wad of shredded toilet paper over the glass, retreat, and resume my gaze. Yes, I look best from a distance. Best in natural light.

It is now certain that Carol will not, as I have been fantasizing, join me in New York at age fifty-three to reclaim the acting career she forsook in her twenties in order to have a family. I think about all the leading roles I saw her play in various Kalamazoo theaters. I recall an annual production of *A Christmas Carol* in

DAY OF THE DEAD

which Carol once portrayed all of the three ghosts who visit Ebenezer Scrooge, transforming herself so thoroughly that most of the audience believed they had watched three actresses play the parts. I also loved her performance as Nellie Forbush, the ingénue in *South Pacific*, which Aunt Carol played well into her forties. But I was most taken with her portrayal of Audrey, the battered and ditzy New York flower-shop clerk in *Little Shop of Horrors*, which I had thought both outrageous and tender. While the platinum wig had been far from convincing, Carol had —well, she had *dyed her bones blonde for the role*, I think. I close my eyes to envision her: she first tears across the stage in treacherously high heels to escape the jaws of an overgrown Venus flytrap. Then she belts out "Suddenly Seymour," the overwrought showstopper in which Audrey portrays her nebbishy, terminally nerdy coworker and newfound love interest—the eponymous Seymour—as a messianic figure able to save her from peril and redeem her life.

I remember Carol's pout. It seems to me that she possessed muscles in her lips that others do not. She made them shimmy like Gypsy Rose Lee and shiver like Tiny Tim. Carol's lips were an actor unto themselves. I consider her presence and the power of her silence. Carol could *turn on* pain. It wasn't like she had to *do* anything. She could just walk onto a stage, blink, lift her head, and it was there. The room filled with crisp air. Her words cut through it. You could see her breath.

Our contract is an old one, my aunt spoke in *A Christmas*

Carol another year, when she portrayed Scrooge's boyhood love, Belle, a figure summoned by the Ghost of Christmas Past. *When it was made, you were another man. That which promised happiness when we were one in heart is fraught with misery now that we are two. How often and how keenly I have thought of this I will not say. It is enough that I have thought of it, and can release you.* My throat tightened as I watched and listened. Her delivery was so subtly plaintive that I concluded she couldn't be acting. On the contrary, she must be acting in her daily life, I thought. Once on stage, she must allow herself to shed the many illusions of contentment, revealing a persistent longing that flows like groundwater beneath her surface at all other times.

Today is All Souls' Day—or, in Mexico, the Day of the Dead, the annual opportunity for spirits that have passed to commune with the living. Carol died only yesterday. Is her spirit already back? Is it in Mexico? I cry again. I throw myself on the floor, heave, and make an "mmm" noise that sounds mournful and hypnotic, like a distant alarm. I sniffle as I get up and look back into the mirror one more time. I watch a tear roll down to my lips, augmented today by the residue of Plum Wine lipstick.

This morning I went to a callback for a role on Broadway for a show I never heard of. It went OK, I guess, but I won't be heartbroken if I don't get it. It wasn't my idea after all—I have usually avoided the humiliating ritual of auditioning and never liked musicals unless Carol was in them—but the casting people just called me out of the blue. Apparently they saw me in a small

venue downtown, reading my stories and shapeshifting into different characters and thought they might like to see me in drag on the Broadway stage, so this morning I threw caution to the wind, modulated my bass voice into a jazzy mezzo and delivered a breathy rendition of "The Boulevard of Broken Dreams" a fifth above my usual key. I imagined Carol in the room, guiding me, looming in the corner in her Dickens cloak. Toward the end of the song I tripped and almost fell, as I am not a pro at wearing stilettos. I tried to exaggerate the trip, pretending to be merely stumbling over a particularly large and dangerous broken dream. The director thanked me and handed me my handbag. "A lady must never forget her purse," he snapped.

I meet my girlfriend Erin on the street and take a car to the airport. We have been together three years now. Of course I am not what someone would call a "heterosexual"—at nineteen I thought I might never date girls again. I thought, in fact, that I'd probably never date anyone again—I threw the baby out with the bathwater, deciding then and there that romantic love itself was corrupt, a cult, a distraction, threatening to entangle me and, like it did to Kim Novak as Gil in *Bell Book and Candle*, rob me of "my powers." Then Erin, the toast of the lesbians, came peeling into the frame from out of nowhere, like a Looney Tunes anthropomorphic taxi. She entered my life sputtering, wheels about to pop, headlights for eyes.

I first encountered her at a student performance-art event during our sophomore year at the University of Michigan. Most

of the acts on the bill that evening were mediocre—I only recall a burlesque number that achieved as much sensuality as that of the narrow aluminum seats the audience members had wedged their asses into and a fifteen-minute "visual jam session" in which several graduate students slopped acrylic paint around to make a madcap 9/11 remembrance mural. Then Erin strode onto the stage. She was physically striking—her jaw jutted way forward and both her eyes and mouth looked too big for her face. Her features were like hyperactive siblings, competing with one another for their parents' attention. She wore torn-up socks re-fashioned into bracelets, a miniskirt, knee-high boots, and a tank top with a giant tiger on it. "To quote the Language Poets," she announced, "'let us not be dominated by the tyranny of meaning.'" With that, Erin began to strip, removing articles of clothing one by one and with a perverse satisfaction, as though she were dismembering a body and forcing you to watch. (In a rare journal entry, written on this night, I scrawled, in particularly unwieldy cursive, "It didn't feel like she was doing burlesque. It felt like burlesque was a demon she was exorcising.") Finally, while yanking off her pink wig to reveal a shaved head, Erin completed her transformation into a gruff bedlamite she introduced as "Ralph." Ralph wore only a dingy pair of men's briefs, jerked off a big yellow highlighter in place of a penis, wiped slobber from his lips with his forearm, and barked phrases such as "I don't remember eating anything that didn't end in '*izza*'!" and "I don't remember barrelin' outta my mom's vagina hole, but I'll

bet she does!" Each statement itself came "barreling" violently from the mouth of the character, and it occurred to me that "Ralph" referred as much to the verb meaning "to vomit" as it did to a man's name. Finally the wanking tyrant began hollering "Cabbie!" at an unsuspecting girl in the audience. He demanded that she come onstage and drive him to hell in an invisible taxi only he could see. "Gotta take it outta park first, dumbass."

I was smitten.

I was happy to see her on the first day of a performance-art class the following semester. In line for the bathroom during break, I overheard Erin talking to another girl about her psoriasis problem. She flicked flakes from her shoulder as though tapping ashes from a Cuban cigar. "You have psoriasis?" I piped up. "I can relate because I have eczema, actually." (This was true.) So she and I bonded over our skin problems.

In class we worked on an absurdist scene together, an addendum to "Goldilocks and the Three Bears." She played Baby Bear, lumbering after me and tugging at my hair, which had been tied into pigtails. For the finale we tackled one another, collapsing together hard against the stage. Each day we left class with new bruises. When the two of us began having sex in Erin's red-walled bedroom, we kept up a playful violence. We wrestled, spanked, and bit one another. Before either of us knew it, we were "a thing." We spent long afternoons and nights together, listening to Jimmy Scott recordings. Erin became so affectionate toward me that she would slip and call me "Dempsey," the

name of her family dog. Erin and I agreed early on that our partnership was not "straight." After all, she was sometimes Ralph, and sometimes another, zippier male alter ego named "Hardy Dardy." I myself sometimes performed in messy drag, wearing a dance recital costume intended for a nine-year-old girl and calling myself "Lap Peach." We viewed our partnership as the union of two exotic creatures with genders in perpetual motion.

Erin and I took a class together, "How to be Gay," which explored artistic movements and genres that homosexuals had latched onto over the years—opera, disco, musicals, et cetera. The class was controversial and we often had to wade through camera crews and protesters to get in the door. We were both captivated by the presentation of Judy Garland singing "The Man That Got Away" in *A Star is Born.* Judy struck these big arms-out, clichéd Broadway poses—but violently somehow, as if she were a victim of involuntary motion, her hands clawing at the air. "Judy's got pigeon eyes," Erin whispered. She's always going on about how over the centuries pigeons had been driven mad by humans' contempt for them. We learned about Garland's funeral, and about the riots that occurred only hours later when police raided the Stonewall Inn and drag queens fought them, marking the beginning of what is known as "Gay Liberation." Erin and I wondered if gay life was more fun when it was played out in shadows.

In many ways, our relationship has turned into a game of revealing and concealing. For example, the two of us agreed, at

first, to adopt the Sartre/de Beauvoir arrangement: hooking up with other people is OK as long as we tell each other. Several months later we made a new deal: hook-ups are OK as long as we *don't ever* tell each other. Both of us sleep with members of the same sex often, but we conceal that fact from our families. I tried to come out to my mother late one night last December, after she overheard me on the phone with Erin, referring to myself with a strange new label as I sat in the dark by the Christmas tree. "I don't want you to be that," my mother said, entering the room once the call had ended. "I don't want you to be . . . 'queer,'" her voice strangled the word with quotation marks. Maybe she had a point—it was sort of a pretentious term that I had reservations about myself. Since both "queer" and "performance art" were elusive categories for that which didn't belong elsewhere, wasn't saying you were a queer performance artist just a fussy way of saying you were nothing? I thought so, but I sought refuge in these words as places for the placeless. Every ghost wants a body, every talking beast wants a name, and I knew this one could be mine for a while. "But I am," I stuttered.

Erin came out in the past, too. Apparently her parents were disgusted that her butch girlfriend "wasn't even pretty." She stopped talking about it. So did I. We tacitly allow our parents to understand us as being straight.

On the other hand, once Erin and I moved to New York together, we began to closet our relationship within gay circles.

The two of us started doing a nightclub act together in which we sang an epic mash-up of schmaltzy doo-wop songs and explicit postings culled from the internet, a tour de force medley of vulgar yearnings. Backstage one night a drag queen chirped, "It's cute when a dyke and a fag are besties," and neither of us bothered to correct her. Besides, "besties" felt apt enough.

Now, on the plane, Erin and I hold hands under a blanket. We begin touching each other's crotch. I lower the snack tray and open the *New York Times* over my lap to shroud my sudden erection. I slide my finger, helter-skelter, across the Dining Section, hoping that my occasional gasps will seem to my fellow passengers to be mere expressions of dismay at the extreme regimen set forth by the "Hollywood Diet."

Carol's funeral is held in Richland, a small and dusty village, which I now realize is only twenty miles from my hometown, but which I'd always thought of as a distant planet, so far away that there might even be another version of myself knocking about over there. Erin and I have borrowed the family Buick LeSabre and are headed to the funeral on the early side, so that I can run through "Ave Maria" with the pianist. We see many fields, gas stations, and fast-food places. We pass many churches before we find the right one. It has aluminum siding. Erin and I walk in and find the open casket.

Carol's cheeks and eyes look fine, but the lips—the corners of the mouth have been awkwardly bent upwards, undoubtedly

to make her appear "at rest." But the expression is jagged. Not just inappropriate but unnatural. Still, I want to touch Carol, to press my face against hers, to kiss her. I want her cold flesh to shock my lips. I turn away from the casket and am startled to find that Erin and I are not alone in the room.

Carol's ex-husband Terry shakes hands with the minister, as though the two of them are closing a deal. He had stepped in to organize, and pay for, the funeral. "All right, girls," Terry says, turning to his daughters. "I want one of you to work each side of the room when everybody gets here. Ange, you take the door. And Melanie, hon, you get the casket. Daddy's gonna move around a bit," he grins. "Can't have all the beautiful girls in the same place!"

Two years ago, in the midst of what is popularly known as a "mid-life crisis," Terry divorced Carol, after having an affair. Carol found an email in which Terry's mistress Debbie addressed Terry in terms of endearment and referred to Carol as "Grizabella," the old has-been who sings "Memories" in *Cats*. When Terry left, so did the rules of the home. A decadent era began in the basement, where Angie had begun lowering the back patio blinds and drinking with her delinquent friends. ("It's getting so trailer trash over here," Melanie had gleefully related to me over the phone.) Carol began drinking, too, but was hard on herself for using alcohol to cope, even a little bit. Some extended family members suddenly suspected that Carol had

been self-medicating for years, and only now was less careful about hiding it.

Angie had a role in last year's *A Christmas Carol* at the New Vic, along with her mother. One day Carol caught Angie smoking in the dressing room. Rather than reprimand her, as she had done in the past, Carol asked, instead, to bum a smoke. So they became two bad sisters, smoking, drinking, and acting.

I now watch Angie slinking off for a smoke break, taking leave from "casket duty." "Come with?" she asks, motioning to the door. Erin and I follow her. Angie is distraught by her mother's death, but she doesn't show it. In fact, she starts entertaining Erin and me with her impressions out in the parking lot. She is able not only to sound just like Cher, but to perfectly mimic the mechanical effect of the auto-tune feature used on the vocals of the dance hit "Believe." Between hits of her cigarette, Angie reembodies the cyborg-like sounds of the song, moving her arms in an inhuman spasmodic way, as though they have become a pair of broken windshield wipers calling up the afterlife, not life after death but "life after love." Erin, in turn, offers her Britney Spears imitation, emphasizing the baby-like aspects of the singer's voice, eventually breaking into a sustained infantile wail.

Back inside, Melanie and I hug. I am ready for her to cry on my shoulder, but she remains composed, telling me "Mom loved you so much. I know how much you loved her, too. I know this

is hard." I am certain she and Angie are suffering more than anyone, yet they are taking care of the rest of us; they are protecting their grief by hosting ours. Melanie turns to greet Terry's family members, as they begin streaming in. They are all Nashville showbiz people, hyper tan, and wearing cowboy boots. Terry's brother Barry strides in with a pot of flowers. He is a man whose avuncular demeanor is so essential to his persona that he is known by all, regardless of their familial, personal, or professional relationship to him, as "Uncle Barry." Uncle Barry swaggers past me in a white sports coat and says "Ah hear yer singin'." Before I have a chance to confirm this, he teases, "Well nah that's not troo—Ah ain't *heard* yer singin' yet. But Ah do hear yer gonna." He leans in. "Y'know Ah sing too. Ah sing by letter. Open mah mouth and *let 'er* rip." He winks and continues on past the casket, turning back to bellow, "Mah brother asked me if Ah could sing tenor. *Ten or* fifteen miles away!"

Terry's sister, Aunt Missy, pops her frost-tipped head through the door like a prairie dog. "It's famly prayer time," she solemnly whispers. We are all led to the "youth group room," which is decorated in war motif. There is a mural of fighter planes on the back wall, with vast orange explosions set against an aqua sky. The other three walls are painted in camouflage and have netting strung across them. As both families bow their heads, I continue to scan the room. I notice a piece of paper, taped up to the door. It says:

What Would Jesus Do?

1. Make sure all the windows are latched before leaving the room
2. Clean up any messes, placing waste in the receptacle
3. Turn off lights

I imagine Jesus poking around the room, picking up the stray hairs Mary Magdalene has left behind, and dutifully walking his Reese's Pieces wrapper to the trash can, washing smears of chocolate from the desk with his tears.

In the visiting room, people have been filing in. There must be at least seventy. I spot Dorian Pollock, an artist, and devoted supporter and confidante of Carol's. He is a photographer who stages bible scenes, some of which are tinged with homoeroticism. I recall that I myself posed for him as a teenager, scantily clad, holding a cow skull.

I see Grace, Carol's voice teacher—and mine when I still lived here. She is seventy-five, but comes across as younger because of her vivacity. Carol always said, "No one knows as much about the mechanism of the voice as Grace." She wears a black dress that has long sleeves and a ruffled, flamenco-style bottom. Full of stories, Grace often recounts anecdotes from her own past performances. Today, however, she has taken it upon herself to extol the virtues of Carol's "instrument," as she calls it, and I watch her, over by the picture table, educating a cluster of middle-aged women on the subject. She gestures toward a picture

of Carol as Audrey in *Little Shop of Horrors* (or "*Little Shop*," as it is known in the biz.) "Well, of course this was fun for her. It did not, however, showcase her tremendous range, her flexibility, the magnitude of her instrument, or her incredible . . . vocal prowess. Not the way that, oh, say, 'Glitter and Be Gay' did." The women nod, and one widens her eyes considerably, mouthing "oh," though it is clear she hasn't a clue what Grace is talking about. "Why, some people are stunned. *Stunned* to hear that she sang it. They say to me 'Grace, you don't mean—*Carol* could sing "Glitter and Be Gay"??' And I say: 'Why, yes. She could!'" She pauses, tears up, and shakes her head. "Boy could she ever."

"How is the 'Ave Maria'?" she asks me under her breath and out the side of her mouth, as though she is a spy talking to another spy. "I wish you could have flown in earlier so we could have run through it."

Just then, Missy resurfaces to usher everyone into the sanctuary. Once we have all filed into it—a modest, carpeted auditorium—and taken our seats, the sermon begins. "Carol was a beloved mother and wife," says the minister, who wears off-white and has a bushy moustache that conceals the expression of his mouth. "And, uh, actress," he adds quietly. "She was also . . . a woman of faith. Carol made no secret of her devotion to our lord and savior," he says, smiling out to the congregation, as though expecting a wave of laughter and head nods. "Oh yes, she loved Jesus above all else."

I remember Terry and the girls being very religious, and always imploring me to let Jesus into my heart, as though he were a friend who just needed somewhere to crash for a few nights. But Carol had been different. Sure, she went to church, but she never even mentioned Jesus. I assumed Carol and Jesus had a cordial relationship, like they put up with each other. I didn't think Carol loved Jesus *above all else* and if she had then it was every bit as secret as her drinking. Was it not vodka, but Jesus, that I smelled on her breath last Thanksgiving when she rubbed my head?

"Loved Him, loved Jesus," repeats the minister. "Now dear Carol, she's taken care of. She's up there," he says, pointing towards the ceiling. "Carol's a good'n. No need to worry about that. What's the worry now is where the REST of you are going."

"Good'n?" Erin mouths with indignation.

"Temptations abound. We all sin. And some among us have not said yes to His love." The minister continues in this manner. His sermon remains more geared toward converting the congregation to fundamentalism than toward remembering Carol.

Once the sermon ends, it is time for me to sing "Ave Maria." I walk to the podium. Trying not to fidget, I take a breath and begin. I close my eyes, and try to transform my voice into a kind of weather that will stir the room. I hear a woman in the back row begin to sniffle. I open my eyes and look out into the congregation. I see Terry and that smile still plastered on his face. I

see Grace, who is motioning for me to stand up straight. I see Erin, and the pools of her eyes.

Then I see someone else—a man with glasses and one little earring. I can't place him. I see another man, with sunken cheeks and a goatee. I know him—but from where? I see a third man—a heavyset black man. He is familiar too, somehow. And it creeps up on me. Slowly I realize these are men I know from the gay bar Brothers. I went there, secretly , all the time when I was seventeen. I often ventured to the place alone, though the first time I went there I cajoled friends from school into coming along, convincing them that my interest in this seedy homosexual subculture was completely ironic, or even anthropological. I remember that night when my friends and I finally located the well-hidden speakeasy of flamboyance. We pulled into the parking lot and were suddenly bathed in the light of a big glowing pink pelican, a totem of frivolity erected by the exotic tribe of queens we had yet to meet. Brothers had male strippers downstairs—one was named Dakota—and a patio with tiki torches, and a performance room. The black man, I realize, is a drag queen—Hope Chest, "the most bounty in the county." She lip-synced to dance tracks and sat on men's laps whether they wanted her to or not! I'd always considered her a sort of drag juggernaut. I remember her referring to HIV as "the booty flu."

Now more and more become visible, as though I'd walked into a dark room and my eyes were just now adjusting to the

light. They emerge like twenty candy-cane-striped shirts in a *Where's Waldo* book. Every gay man I ever knew in Kalamazoo is sitting here, wearing black. Suddenly it dawns on me: *Aunt Carol is the Judy Garland of Kalamazoo.* Why, it makes sense. True, it's forty years later, but news of gay liberation has yet to hit West Michigan. And this is why she has died: so that they can be liberated.

Now it's all coming back to me. The man with the earring is a bartender, and the man with the goatee is an actor—the last time I ran into him, around last Christmas in some department store in downtown Kalamazoo, he recognized me and asked me, in hushed tones, if my aunt was OK, informing me that she had dropped her purse at a rehearsal and bottles of pills had spilled out. *Just like Judy*, I think, singing the final words, *Ave Maria.*

I sit back down. The minister, wielding a white remote control, activates a DVD. It contains a series of scanned photographs of Carol from throughout her life, which flip around and grow and shrink in slightly zany ways. Look, there she is in a family portrait from the eighties, before her nose job, when Angie was a baby. Oh, and there she is in her black-and-white headshot in the nineties, after the nose job. And there she is on the beach, wearing a clown nose. The music behind the sequence alternates between recordings of Carol and recordings of Judy Garland. And one Frank Sinatra song.

This goes on for fifteen minutes and then, after lingering on

her most recent headshot, the video cuts to something else. Something live. There's a stage. This is a performance. As the camera comes into focus, there is Aunt Carol, wearing a low-cut black dress. And a big blonde wig that wasn't trying to pass as hair. Her makeup is streaked. A terminally nerdy man with pants pulled up well above his waist tears off his glasses and plants his feet firmly on the stage, assuming a classic hero stance.

Lift up your head, he coaxes, in speak-sing. *Wash off your mascara. Here, take my Kleenex, wipe that lipstick away. Show me your face, clean as the mornin'. I know things were bad but now they're okay.*

My mother, two seats down, shifts her body and looks troubled, maybe recognizing the video to be footage of *Little Shop of Horrors*, and wondering if it is appropriate to play such a camp classic at a funeral. Or perhaps the sight of her dear friend is simply painful. The camera zooms in and Carol begins.

Nobody ever treated me kindly, Carol whispers in a put-on nasal voice. *Daddy left early, Mama was poor. I'd meet a man and follow him blindly. He'd snap his fingers. And me? I'd say . . . "sure."* Carol takes an audible breath through her nose and steps firmly into the spotlight downstage to belt with a vocal depth she has been concealing. *Suddenly Seymour! Is standin' beside me.*

He don't give me orders! He don't condescend! She tears at the air with tenuously pressed-on nails. The vibration of her recorded voice, the thunder of her hidden instrument, fills the church with an electricity so strong that even the hairs of the

DAY OF THE DEAD

minister's moustache seem to lift, revealing a slightly open mouth. He clutches the remote.

Please understand that it's still strange and frightenin'—for losers like I've been it's so hard to say.

I can feel everyone in the room. After the string of still images everyone is startled to see Carol's body in motion, to feel her voice. We all try not to break into tears, but like a shelf of shot glasses set before a cartoon soprano, screeching out her stentorian high C, one by one, we shatter.

Suddenly Seymour! He purified me! (He purified you!)

Suddenly Seymour! He showed me I can. (Yes you can!)

Learn how to be more the girl that's inside me. With sweet understanding . . . Seymour's my friend.

A man blows his nose like a trumpet. Tears pour out of me. Tears are everywhere. My father, next to me, he's wringing out his sadness. Grace, in the front row, she's dabbing under her glasses with a black cloth but she can't dab fast enough. And Erin, too, she's weeping with her giant eyes.

After the service Erin and I borrow the Buick and steal away, driving around a while. I take her on a guided tour of teenage landmarks, such as "the waterfall," a dam in the river behind the Kmart, where my friends and I used to hang out and smoke pot. I point out the twenty-four-hour Denny's on the side of the highway, where I occasionally commiserated with strippers, Hells Angels, fellow teenage ne'er-do-wells, and other creatures of the night. I drive past the big industrial building where I took

lessons from Grace and where local artists dwell; it's practically the Chelsea Hotel of Kalamazoo. We drove through the nearby quaint village I grew up in.

"I can't believe this is where you come from. How did that happen?" Erin says, laughing as though I had just done something embarrassing, which she, in turn, finds endearing.

Then I tell her I am going to show her a secret place, my old haunt. I imagine all of the gay men have already congregated, ordering their cosmos extra strong, knowing they'll be watered down with tears. I imagine Hope Chest doing a Carol tribute, singing "I'm Gonna Wash That Man Right Outta My Hair."

I coast through the bad part of town, barreling past the strip club, Déjà Vu Showgirls and Love Boutique, and then the adult bookstore, simply called "Adult Bookstore". And I know we're close. I turn down the ever-dark Stockbridge Street. I drive up and down before I find it—this deep area of darkness where the unmarked bar has always stood, lit only by its own tiki torches, Christmas lights, and big glowing pelican.

Strange, neither the glowing pelican, nor the other lights are there. I pull into the parking lot, and as my eyes adjust, I see it: the skeleton of a building that has been burned down. There is only a corner of wall left. Charred but intact, it resembles a ravaged obelisk. Spray-painted in silver are the words "Die fagg's."

I turn off the car and Erin and I get out. I stir up dust as my feet, still tucked into dress shoes, crunch against gravel. I put my arms around Erin's waist and hoist her up to the hood of the car.

DAY OF THE DEAD

She wraps her legs around me. I trace her boldly pronounced collarbone with my index fingers. She and I lock into a kiss. One time, early in our relationship, Erin told me boys kiss with their tongues and girls kiss with their lips. She's kissing with her teeth now, and I have lost track of where my lips end and my tongue begins. The nearest light is a hundred yards away, at Sally's Beauty Supply Shop, closed for the night. Erin and I are in a blanket of darkness, a Michigan black hole. The old Buick Le-Sabre, usually sky blue, is just a shape now.

As the engine cools and the hood of the car is chilled by the November wind, Erin and I become the warmest thing within eyesight, a hidden pocket of breath and saliva. I relish this sensation, and will remember it. I will treat it as though it is one object among many, carved intricately, whose shape and surface I recognize by touch. And I will reach in and feel around for it sometimes, having hoarded it *here*, with my other secret moments.

VOICE LESSON

I walked to the third floor and waited by the door, which read "Grace's Voice Studio." One of us was always late. Today it was Grace. She appeared on the other end of the long industrial hallway. "Hello!" she called. Her greeting echoed through the hall.

Today she wore pink capri pants, a pink tank top, and some matching pink platform sandals, which elevated her slightly above her short stature. If it had been winter she would have been wearing a sleek babushka or fur animal-print hat with some massive and flashy coat whose function seemed incidental, just happening to be very warm in the middle of the Michigan winter. Similarly, the pink ensemble's function felt secondary. The pinkness was likely to remind someone only more intensely of the flesh it covered. I thought it was brave of a seventy-five-year-old woman to venture so in fashion—I was a teenager at the time and free-spirited old people transfixed me. Grace hugged me and smiled.

She unlocked the door of the studio, which was littered with ancient issues of *Opera News* and piles of antique scores. A stained and tattered copy of *Norma* lay open in the corner.

That's the one about a druid priestess who prays to the moon and self-immolates at the end. Opera was new to me. I was a white boy who really wanted to be a blues singer: I barked out dirges, sitting hunched over the piano and stabbing at the keys, but I couldn't even make it through one song without losing my voice, so I had begun taking classical lessons. Grace said she wanted to teach me "to breathe," "sustain a line," and be "unified from top to bottom." In opera your voice was supposed to remain unbroken even in the midst of distress, even if you were singing about *being* broken, whereas in blues your voice was allowed to tear and snap apart and even sound like different people in different octaves. This multiplicity and uncertainty made existential sense to me. But Grace was getting me into opera, too. "Gruesome and gorgeous," she remarked in a luxurious tone, describing a Russian aria about someone impaling a family member—or something. I did like that: the cruelty of opera, the fatalism. The sense that once it has begun, the opera will deliver its characters to their fates like a train that can't stop.

Grace led me to the upright piano in the next room. "Look at your hair," I teased. I noticed she had just gotten a perm and dyed it burgundy. She turned around.

"Do you like it?" Her eyes widened as she half smiled. "I couldn't tell if I did at first. *Until* I went to a piano recital at the festival yesterday . . ."

Grace was about to tell a story—I knew. Our lessons some-

VOICE LESSON

times went on for hours, and half of the time was dedicated to her recitations, her anecdotes. She told me some stories again and again, and yet was always adding new ones to the repertoire too. I stood still and listened.

"The singer was superb, and more than that, the pianist was amazing. They were playing French impressionist songs—Ravel, Debussy—effervescent, ethereal. Have you ever tried?"

"I played 'Clair de lune,'" I offered.

"Oh, that's the easiest," she replied disappointedly, brushing her hand through the air briefly, as though to erase the moment. "Anyway, very complex, sensitive music. *Well*: I struggled in the darkness to read the program they'd given me—I'd arrived late—and I couldn't *believe* the name I began to discern. Josiah Kazan. Josiah Kazan! You see, in . . . must have been the late sixties, he accompanied me at a nightclub! In Fort Lauderdale . . . I had been given some poetry and asked to extemporize. So I sang the poems, improvising coloratura passages—very high," she crossed her eyes, motioned upwards and laughed, then lowered her chin. "Very avant-garde."

"I can imagine," I said.

"So anyway, during the performance—yesterday's recital, that is—his eyes kept darting from the piano over toward me. Only for fleeting moments, mind you. Then, after the second encore, as he stood on the verge of a bow, he paused. And stared straight at me. Then he whispered, 'Could it be?' And I replied,

from the dark third row. 'Yes, Josiah. It is I, Grace.' For that moment it was as though forty years had not gone by, and we were in that little nightclub after-hours, in the wake of performance, gazing at one another."

"Whoa," I commented, nodding and raising my eyebrows.

"Do you understand that I had to alter my appearance in order to be recognized?" she asked, with a sudden urgency. "Now *that* is paradox."

In our lessons Grace spoke constantly of paradox. It was her guiding principle, her idée fixe. She designed all vocal exercises herself and made sure each revealed a paradox. For instance, she made me sing the words *down the little hill* on an ascending five-note scale, then *and up again* on the way back down, so that the words always went in the opposite direction of melodic movement.

"You do realize that from here up I look the same?" Grace, still intent on making her point, placed her hand horizontally beneath her nostrils in a karate chop formation, bisecting her face. "I realized at this moment: *this* is why I dyed my hair! So I could be recognized by my past. And since yesterday I have felt good about it."

"Well, you should," I offered. "It's a lovely hairdo."

Grace laughed. "Well, anyway," she said, turning toward the piano and deciding to commence the lesson, "Give me your puppy whine." My lips sputtered as I blew sound through them,

sliding up to my high notes and plunging down to the low ones. "Faster! Get to the low notes faster," she urged. "Those are your money notes!"

We went on for some time, working on single-phrase exercises, starting with *That's the very finest thing that I have ever heard* and then moving on to *It's me, hey I caught you.* Grace encouraged me to enunciate more clearly and make sure I was breathing deep. "Now emote! Emote, for god's sake! Who are you? Who am I? And why is the fact that you're catching me an interesting event?"

Huh, good point, I thought. "Sorry," I said.

"Choose any emotion," she continued, raising her right hand in the air. "And if you emote, your deep diaphragmatic breathing will be engaged automatically. Emotion discloses life," she moved into a whisper, as though revealing the secret of the universe.

Grace embarked on another anecdote. "You know, one of my students who sang at New York City Opera used to fly me in to give him lessons prior to performance. One evening he was reaching, *struggling* for the notes. I said, 'Thomas, my dear, you must let the *breath* do the work. You cannot *do it* with your *throat*.' I warmed him up and got him to *believe* in his breath. Then Thomas asked the big-time New York coach who was playing for him, 'anything to add?'" She paused and twisted her lips into a crooked grin. "The big-time coach replied, 'Yes. Listen to Grace.'"

VOICE LESSON

She relayed several more stories. She told me of training a "folk singer"—a title she uttered quietly to evoke something unsavory—thirty minutes before a performance to bring the ravaged voice back to life, to purify this vocal promiscuity. Grace also told me of past students who were "led astray" by other teachers, only to have their voices "ruined" before humbly asking Grace for admittance back into her studio. The moral of each story was: Grace is correct, Grace is needed, Grace rescued the doomed performance.

We proceeded with another round of *It's me, hey I caught you.* I tried to emote, but emotions struck me as cheesy, uncalled for, and unsightly, so I mainly stuck to singing the notes. Grace was upset with my lack of "emotional motivation."

"Emotivation?" I asked. Grace feigned a laugh and then sighed.

"I try to be expressive in my teaching in order to show you. But if I am sometimes unenthusiastic, it is simply because of my chronic fatigue syndrome." Grace pronounced those three words with vigilant diction. She occasionally mentioned suffering from this condition. At the time I found it preposterous that Grace could have such an illness. Incredulous, I was convinced it must be a psychological issue—a hypochondriac's flight of fancy, or just comforting code language for "being old." Brimming with chutzpah, Grace was the most animated and sprightly person I had ever met. She demonstrated vocal exercises with wild expressions on her face, and moved her body in a strange

way—both loose and stiff, controlled and uncontrolled, like some joyously depraved marionette enticing its human audience members to become puppets themselves—as some diabolic technique to trick innocent people into acting, no doubt. *Let your strings be pulled, yes that's it—let the spirit have its way with you. Emote, my precious ones, emote!* I had also known her to salsa the whole way out to her car after lessons, rather than simply walking there.

These daring moments did not mark the height of Grace's energy. I witnessed this during my junior year of high school. I'd auditioned for the Elvis-like role of the Pharaoh in *Joseph and the Amazing Technicolor Dreamcoat* because I thought I could excel at gyrating around, and they agreed and cast me. But lo and behold, they expected some technical choreography, so Grace took it upon herself to coach me. She confessed her love of Elvis, even though he wasn't an opera singer. "Believe it or not, he does use the correct resonators," she told me, blushing. She rose up from the piano to show me the dance moves of the King. First she demonstrated the way Elvis kept time, shifting his weight from one foot to the other every four counts. This was only a prelude to a demonstration of his trademark move, "the pelvic wind up," Grace called it. In this maneuver you were supposed to grind your hips in a circular motion, lingering on *pelvis out*, while swinging one arm in front of you like the hand of a clock that's spinning so fast it's about to break free. Then, in order to end the move, you were supposed to fall to your knees as

though overcome by your own mojo, raise your hands up, and skid across the floor. Grace executed the move potently, grinding at the cosmic axis of her crotch; I learned the sequence but can't claim to have executed it with the same fervor or flexibility.

Chronic fatigue syndrome? I repeated silently. Another paradox. Grace had me sing a few more of her exercises. She instructed me to sing *that cat has fleas* on a single tone, moving up the scale in half-steps. Later the words switched to *the dog has fleas* and then *do you have fleas?* and *I too have fleas!* In this slow-growing horror of chromatic ascent, everyone in the world eventually was revealed to be infested with fleas. At one point I coughed. Grace stopped playing the piano and turned toward me.

"Does he smoke?" Grace asked me, perhaps trying to trick me into telling the truth by referring to me in the third person. I did smoke. I had adopted the practice as part of a general effort to become a juvenile delinquent, an effort that was none-too-aided by my learning bel canto arias, I might add.

"Smoke? No," I lied. Grace proceeded, nevertheless, to assure me that vocal redemption was always possible.

"Well, if you *did* smoke, and you quit today, your lungs *would* be pink again in three years," she smiled. I appreciated her assurance, and the fact that she wasn't lecturing me, especially since she had castigated me viciously last week for sneezing, as if sneezing would be my ruin. "You know, your heart stops every

time you do that," she'd warned, as I dug through my pockets for a tissue. Anyway, I wasn't going to tell her this but I planned to quit smoking before I turned eighteen— I knew that like stolen candy, underage smoking simply tasted better.

"Aside from smoking," she went on, "you should watch out for alcohol. I drink in strict moderation. Of course," she ran her fingers through her hair, "you do always think you sound marvelous when you're drunk! I remember the night I sang 'Un bel di' from *Madama Butterfly*, after drinking whiskey with a bunch of nuns—the nuns drank, too, gross amounts of whiskey. You might not guess it, but nuns do drink." I nodded, wondering what Grace was doing tarryhooting around with this gaggle of nuns, though I didn't ask. "Anyway, I felt moved by the spirit that night, so to speak. I felt like a star." She paused. "I didn't drink so much after that."

Grace was always giving me remedies, elixirs, restorative procedures. "To clear out your sinuses," she often told me, "make sure to snort hot salt water. Hot. As hot as your hand can stand. And boil tea in a pot and inhale the steam, with a towel over your head. And then drink the tea, of course. At least four cups." The remedies usually worked, as it turned out. Above all, the lessons themselves were revitalizing. It was clear that Grace sometimes used our sessions as therapy for herself, a good old *talking cure*, and likewise, I specifically thought of the lessons as my alternative to psychological counseling, a *singing cure*. As is typical for teens, I experienced myself as being lonely and full of trouble.

VOICE LESSON

Though I had always felt old and wise as a child and had begun my teenage years feeling already beyond them, I eventually started courting a sense of crisis, almost dutifully, as I knew teenagers were supposed be dramatic, petulant, and disturbed, and I didn't want to miss out on the thrill of it all. Soon enough the crisis became me, and lately I'd even been sleeping with a knife under my pillow so that suicide would be a convenient option, should I awake with too sharp an existential pain at some point during the night. But when I was using my voice in the lessons with Grace, it was like a meditation, far away from anything else.

Although her job was to teach people how to *do* something, for Grace it seemed that everything was a project of undoing. Undoing what you'd done to yourself and that which was done to you, a clearing out and letting go. She was always coaxing me into releasing muscles I didn't know I had, or begging me to stop speaking in a Midwestern accent. "Those vowels are flat," she gasped. "We want round and pure!" Smoking, drinking, illness, regional dialect—these actions and origins are all recorded in the voice and when a person speaks there is history, autobiography, texture of experience etched into the sound. In opera all of this apparently needed to be washed away, so you could transcend the character that was yourself and shift into some grand vessel of universality.

"All right, let's move into 'Sail Away,'" said Grace.

"OK," I said, nodding. This was an arpeggio exercise where

VOICE LESSON

you sang the words *sail away* and envisioned your voice gliding across the room, and sometimes out the window and through the air, or onto the roof of the homeless shelter across the street. I took a breath and started singing. I also was supposed to think horizontally, not vertically. On the wall, Grace had hung a painting by her husband, of a lake with a little island in the distance, and I was also supposed to imagine my voice sailing across the room and into the illusory space of this picture, on a voyage out to its painted island. Voices are slinky alter egos that can go places people can't, can pass through small openings better than a bat. "Sail away," I sang. My voice cracked.

"Relinquish your fears and you will be able to hit those notes," Grace advised. "If you abandon yourself somewhat, the note will have focus. That is a paradox! Imagine you are a vast cathedral, with a tall, narrow steeple for the high notes. You must have faith."

"OK," I said, squinting as I tried to reenvision my body as a great achievement of Renaissance architecture.

"But also pretend you are Julia Child, of course," she added as though it should go without saying. She flared her nostrils as she imitated the robust, lofty tones of the iconic chef. "Say 'Hello, I'm Julia Child!'"

"You should write a book called *Finding Your Inner CHILD*," I remarked flatly. Grace laughed and batted her eyelashes.

We then moved into Grace's favorite exercise, the phrase

Grace says she is crazy and I'm inclined to believe her, intoned on a single pitch. She made me speak it deliberately. "Grace says she is cray-see and Ah-eem inclah-eened to bee-leeev her," I spoke.

"Again, with meaning." As I repeated the phrase, I struggled to identify the paradox I assumed must be implicit in the task. If Grace really were crazy, she wouldn't realize it, I guessed. That must be it. Beyond that, I detected a self-fulfilling prophecy here, too: the exercise is brutally monotonous, devoid of true melody, and if I stood here chanting it for long enough we'd both lose our minds. Distracted by my thoughts, my concentration dissolved, and my voice went kerflooey. Grace sighed.

"Does he have faith?" she asked.

"Faith?" I repeated, startled.

"Do you have faith?" she repeated, shifting her tactic, and staring at me with a serious look.

"About the . . . the . . . hitting the notes? Yes, sorry," I stammered.

"No," Grace smiled sweetly as though gazing at a rabbit in a cage. "I mean are you a 'person of faith?'" I was nervous at her asking—my parents occasionally claimed that we were Presbyterian but we didn't go to church much. As a child I'd talked to God often and once depicted him in crayon, as a longhaired shirtless Latino man with a tornado for legs. These days I was not a believer.

VOICE LESSON

"Oh," I replied finally. "I'm not religious, no."

"Neither am I," she said. "And I envy Christians. Because I know that faith is *psychologically helpful*. It gives one the idea that her life could not have been a different story than the one it is now." She paused.

"I think I understand that."

"Do you?" she asked, adjusting her glasses. "You know, I could have gone to a prestigious conservatory. I was accepted to one. But I got a scholarship to a rinky-dink little college in Michigan. Then I left school to get married. Then I raised children. Then I was married again. I wasn't in an opera until I was *forty-five*."

"I thought your first role was earlier."

"Well at forty I was the understudy for the lead role. And the woman they had doing it was abominable. Yes, she was tall and she was pretty. Her mid-tones were . . . decent. She couldn't hit the high notes. So you know what they did?" She paused and looked me in the eyes. "They put me on the outskirts of the chorus, shrouded by the edge of the curtain. And when she had a high note, *I sang it. I sang it from the darkness at the edge of the stage.* And she opened her mouth as if she were doing it." Grace's caricaturish expressions had evaporated as her small mouth clasped shut. She again ran her fingers through her burgundy hair. Her fingers received reflected light from her hair, making it look as though they were being stained with fresh dye. Through the thick lenses of her glasses, I searched for tears, but

I saw only tired eyes. I noticed the edge of the smooth pink tank top against her folded skin. For a moment her look lost its unity and her age seemed accentuated by a costume of youth. A costume of youth—that's what I saw in just this moment. "Don't be like me," she said. I hugged her for long time, and was careful, afraid I might hurt her if I squeezed too emphatically.

Years later, when I heard that Grace had lost her studio space, and that she was home caring for her ill husband, the news distressed me. Her studio had been her stage, where she played out her victorious anecdotes and moral dramas. I imagined that if she were now delivering these stories only to her ailing husband, the situation might be less than satisfying for both parties involved. I never forgot her tale of tragic ventriloquism.

As I continued to perform as a singer, I would sometimes hallucinate Grace in the audience, her face illuminated by escaping stage light, eyes hidden by those reflective glasses. Once I pretended that she was just to the side of the stage, whispering instructions and breathing for me behind the curtain. On another occasion I had a dream that I was Grace, commandeering the stage in an excessive gown, plastered on whiskey. I looked out into the audience and saw a crowd of identical nuns. I opened my mouth and made a grand gesture. And in the periphery, hunched in the shadows, clinging to the curtain strings in a shredded robe, was a crone. "I'm God," she said plainly, and proceeded to bellow out the notes I couldn't find.

VOICE LESSON

TRAIN WITH
NO MIDNIGHT

Remember the 2012 apocalypse? It was big in 2008. That's when various shysters began selling their books by invoking some inscrutable Mayan prophecy, cobbled together with ominous bits of scientific jargon about the magnetic poles switching, and various distressing—and likely accurate—statistics about the environmental catastrophe currently affecting the planet.

At the time I had friends who went around Brooklyn muttering forebodingly about the day our world was to go asunder: 12/21/12. These same people spent the next four years squeezing in every hedonistic life experience they could possibly imagine, and then never mentioned the apocalypse again. When that date finally rolled around, even the most occult-oriented and nihilistic among them approached the coming Christmas weekend with little more than a humdrum air of pre-holiday malaise. Some even went shopping.

I had the distinct sense that my friends weren't *relieved* that this apocalypse wasn't on its way, but that they were *resigned* to the fact we wouldn't all be meeting such a tidy and magical oblit-

eration. Once the world had failed to end on schedule, I promptly came down with the stomach flu in my parents' quaint and cluttered West Michigan home, late on Christmas night, and ended up missing my flight back to New York City. My mother avoided me for several days, addressing me from the other room as "Typhoid Mary"—a name she assigns to any family member who is under the weather.

My father read to me in bed—some meandering essays by Carol Bly, no doubt harder for me to follow in my state of delirium—and he sang me "Dark as the Dungeon" and other bleak lullabies about miners, and hobos on trains, just as he had done when I was a child.

After a blurry couple of days, I awoke on New Year's Eve and felt back to myself again. It was too late to make my evening plans in New York; I discovered that flights were far too expensive, but train tickets for midnight that night were available and reasonably priced. Many people would find the prospect of spending a holiday on a train unappealing, but I am a glutton for awkward experiences. Therefore, instantly convinced that New Year's Eve on a train would be a night to remember, I insisted on heading back to New York that night, by train. Why, I couldn't wait to see all those strangers on Amtrak, whooping it up in the aisles, shaking their stuff in the café car, to welcome 2013. Perhaps some passengers would kiss one another. What a strange situation, I thought: to be in motion, barreling through the night, while arriving into a new year.

TRAIN WITH NO MIDNIGHT

I bought the ticket. At once I contemplated all the New Year's Eves of my past and all the train rides of my past. Tonight the two tracks of memory would converge. Finally the sense of restrained festivity I associated with trains could become, well, a bit less restrained, I imagined. I thought too of the impossible expectations that characterize New Year's Eve—all that heedless drinking in hopes of achieving some unprecedented metamorphosis. At least on a train, I thought, we would have a *reachable destination*.

My parents complied in driving me down to Elkhart, Indiana—the train to NYC is much shorter from that station, and it's just an hour from their house. I sat in the backseat, just as I had on family car trips when I was a child. At one point my mother turned to my father and remarked, "You are going to outlive me. But *if* I were to outlive you, I want you to know that I would never remarry."

My father shrugged and, without taking his eyes off the road, replied, "It's not like I'm gonna be ghostin' around."

Once in Elkhart, the three of us passed several businesses with names so generic as to be almost outrageous: "Easy Shopping Center" and "Quick Video." I didn't know video rental outlets even existed anymore, but this one seemed to be appealing to those who were at once *behind the times* and *in a hurry*.

Vowing not to do it again in the new year, in our fresh new lives which would begin in roughly an hour, my parents and I scarfed down McDonald's cheeseburgers, ordered from the

drive-thru. As we proceeded to the train station, I thought about trains and why I like them so much. For one, the culture of ground transportation in general is much less police-statey than that of air travel; one can express one's personality, even eccentricity, without having to worry about being suspected of terrorism. This is partly because crime on trains and buses in the United States is not so often politically motivated. For instance, that one man who decapitated another on a Greyhound wasn't a follower of any cause—he simply wanted to show off to his fellow passengers. Chatty schizophrenics, the Amish, anarchist types, babies with joie de vivre, temperamental Europeans, the unwashed, and the unhinged—these are the people of the ground. Of course the atmosphere of the train is more sophisticated and delirious than that of a bus. And because the heyday of trains belongs to another era, riding the train makes you feel like you are somehow in the past. Even the most contemporary vignette, viewed through the windows of a slow-moving train, appears to be history.

"Your father had an idea for a sitcom," my mother smiled. "It's about a woman who has six cats, like I do. And when she dies, her husband is left to care for the cats. And *he* can't see his wife's ghost, but the cats *can*. So he communicates with his wife's ghost *through* the cats!" They both laughed. "Don't you think it's a good idea?"

"I do," I said, amused and troubled.

The Elkhart station was small and old-fashioned, currently

quiet and empty. We were the only ones there except for the attendant, who listened to a radio behind her glass window. She looked as though she wanted to be left alone, so we tried not to bother her. We just sat on a bench, watching a clock on the wall, and conversing in whispers. We didn't even raise our voices to countdown to the new year. "Five, four, three, two, one," we mouthed in a huddle, as though marking a tradition in the midst of hiding from a predator. A low screeching echoed outside, precisely at the stroke of midnight. "That old freight train sure dragged in the new year," remarked my father. Then, sustaining our hushed boisterousness, we waited for my train to arrive. It was due at 12:30 a.m.

My train was younger and sleeker than the freight—it didn't sound anything like a wraith as it came streaming through the darkness a half an hour later. My parents walked me outside, we kissed goodbye, and I stepped aboard. I waved back at them from the stairs and then turned towards the future, readying myself for the *real* party.

I found myself stepping through the door into a pitch-black corridor. As my eyes adjusted to the darkness, I began to make out the shapes of people, curled up and draped over their seats. Many were under blankets, cushioned by bulky winter coats: bundled against the world. Some had their shoes off and were snoring. I wheeled my suitcase swiftly down the aisle into the next car. It was the same, as was the next. In each car I found

rows and rows of sleeping bodies—an endless cemetery of the tuckered-out.

Had they simply partied too hard early in the night and all passed out long before the clock even struck twelve? I had seen that happen once at a party in Kalamazoo. Or for most people, was choosing to take a train on New Year's Eve the signal of a certain kind of resignation, an opting out of merriment? I wondered, in distress: Had a few tyrannical early-to-bedders ruined the fun for everyone? Was I the only bon vivant on board?

Finally, in the last car, I spotted one seat with its light on. A man and a woman were there, awake, drinking from plastic cups. *Aha. The last soldiers standing.* I wheeled my suitcase towards them and settled into the seat across the aisle from theirs. "Hi," I said. "Happy New Year!" The man turned to me. He didn't wish me a happy new year but a grin spread across his face.

"Weee like smokin' weeeeeeeeed," he growled happily. The woman laughed.

"We're goin' to 'New York City,'" she said, as though this might clarify her companion's remark. She said *New York City* as if there were quotation marks around it, like it was a city that didn't or shouldn't really exist.

"Not cuz we 'want to,'" added the man.

"Cuz we 'have to,'" said the woman. She paused and then explained, "We're goin' to a wedding." She nodded at me slowly.

"Was there a party on the train?" I asked. She opened her

bleary eyes a little, like someone had just turned on a bright light.

"We're having a party," replied the man, several beats later, holding up his plastic cup. Pink liquid swished around in it.

"I can see that," I smiled, masking my general concern. "What about the other passengers?" I asked. The man stuck his lips out and moved his head side to side, as to indicate *a little here, a little there*. "What happened at midnight?" I asked.

"Midnight," one repeated. They looked at each other, drunkenly and quizzically, as though faced with some tricky bit of historical trivia. *Midnight?* For the life of them, it seemed neither could recall.

I sat in my seat and looked out at the passing trees. Midnight had only occurred an hour ago, I thought. Not even. And it was a rather *important* midnight, after all. I watched darkened backyards and then fields. I began to think about the route of the train. In a moment it dawned on me: the train was coming from Chicago and had to cross time zones once it hit mid-Indiana, where it was an hour later. So if the train crossed at, say, 11:20 p.m., then it suddenly became 12:20 a.m.

It had never been midnight on this train. Its passengers had missed the passage into a new year.

I looked back around me at the people, fast asleep. Slugabeds all, slumped awkwardly in their seats. Suddenly, I viewed them as an unfortunate lot of lost spirits. A zombie clan of sleepers. The ones time forgot. For them, was it even 2013 yet? Or were

TRAIN WITH NO MIDNIGHT

they children of 2012? Orphans of its forgotten apocalypse? And how lucky was I not to be one of them. I *had* my midnight. Why, *I was a citizen of the future*, I thought, gazing out the window at backyards and closed shops.

Or was I? Was I just the one most affected by this lapse in time, the chief mourner of the lost midnight? After all, I'd invested in this train, in these people, a heady sense of possibility. I thought of this night, these passengers, and the entire scenario the way most of us think of each coming year: as a promising stranger. A promising stranger who inevitably disappoints you, as it turns out, once you actually get to know her.

I was getting drowsy myself. The train slowed down and became a bit jerky. Still, I drifted off, becoming one among the sleepers, only waking up for a moment, here and there, as we all went lurching forward on the train with no midnight.

NOTES AND ACKNOWLEDGMENTS

This book was written over the course of more than a decade. Over half of the material is debuting in this collection. Parts were written with the page in mind, then adapted to the stage, and now adapted back again. Though I made revisions to the early pieces, I tried to preserve their character, which at times is youthful or particular to a cultural moment we have now surpassed.

Some episodes and events are represented with absolute accuracy and others did not occur at all. The characters in this book, too, live across a spectrum of fantasy and reality.

I am grateful for the support that has been given to me over the years, by individuals and institutions. A comprehensive register would be monstrous. So I have put together a working list focusing mainly on those who helped specifically with the work appearing here. Because a number of pieces had past lives as performances, the list is already long.

Thanks, first, to my editor, Ruth Greenstein, for her thoughtful attention and direction, and for bringing this book into being.

Thanks to those who read and responded to the book: Elizabeth Gimbel, who has guided and critiqued much over the years. Bryan

Heyboer for feedback and friendship. Erika Rundle for her generous brilliance; Olivia Laing for her meaningful support and also adventures; Gerry Visco for reading early versions and being a proponent.

Deepest gratitude to Amanda Alexander and Chavisa Woods for their engagement with this, and for keeping me afloat in life.

Thanks to Gian Maria Annovi for all he gave to my stories, our life, and those happy years.

Thanks to pals and collaborators Dan Bartfield and Laura Terruso for lending talent and attention to versions of these and related pieces over the years in the mediums of in music and film; Kevin Malony, Uwe Mengel, and Josh Hecht for directing several of these stories when they were performances; Stephanie Rowden, Katherine Weider, and Jay Allison for radio adaptation of Cat Lady; Hari Nef, for her help and feedback as I began to revisit early stories, and Aaron Tilford for responding to and publishing some; Young Jean Lee for encouraging me to continue writing; and Matt Leifheit for giving me an outlet at VICE. Thanks to Eric Jensen for all his support.

I am grateful to Holly Hughes, for her friendship, body of work, influence, and generosity. She made much of my work possible in estimable and inestimable ways.

Thanks to important gurus: Fay Smith, George Shirley, Tony Amato, and Sheila Plummer. John Moran, who showed me some truths of art. I'm thankful also for the meaningful influence and support from my Ann Arbor family throughout the years—The University of Michigan Penny W. Stamps School of Art & Design: Chrisstina Hamilton and The Witt Artist Residency, and John Luther and everyone; Vicki Patraka for her illuminating engagement with my work; Amanda

Krugliak and the Institute for the Humanities; Al Hinton, Niki Williams, Jim Leija, Anne Carson, and many other wonderful people.

Thanks to Erin Markey, Dan Fishback, La John Joseph, Melaena Cadiz, Max Steele, David Cale, M. Lamar, Penny Arcade, and Carol Lipnik for showing up for early pieces included here. Thanks to Bibbe Hansen and Sean Carrillo, Jack Waters, Gary Graham, Henry Russell Bergstein, and Amy Sadao for early support. Thanks to Angela Ashman, Elaina Richardson, Steve Dennin, Jim Fouratt, Sharyn Jackson, Morgan Jenness, Kristahn Farell, Cheryl Young, Dean Klingler, Earl Dax, Ellie Covan, Nicky Paraiso, Michelle Aldredge, Carmelita Tropicana, Matthu Placek, and Lawrence Kumpf for roles they played in certain work being developed, celebrated, or seen.

Thanks to Tyler Stone for letting me print lyrics to "The Gerry Party," and Cameron Ayres for letting me describe "Lotto Love."

Hearty thanks is owed to the Corporation of Yaddo, MacDowell Colony, Creative Capital, New York Foundation for the Arts, Times Square Alliance, University of Michigan, and Franklin Furnace. I developed the early stories for showings at Dixon Place, The New Museum, Envoy Enterprises, La MaMa, Ars Nova, soloNOVA at PS122, and Dublin Fringe. Thanks Afterglow, Abrons Arts Center. Lois, Bob, and Bill—friends at AOP, Ed Rosen. Thanks to Sherry Dobbin and David Terry for giving me space these past few years to develop. Thanks to Chris Hardwick for bringing a larger audience to my work; Colleen Keegan for helping me see and seize new possibilities.

Thanks to inspirations Jaimie Warren, Gio Black Peter, Edgar Oliver. And to lovely Alyssa Taylor-Wendt, Jennifer Blowdryer, Steve Cannon, Dan Levenson, Theda Hammel.

NOTES AND ACKNOWLEDGMENTS

Longstanding inspirations and dearest: Sherry Wiley and Evan Jordan. Old buddies: Jonny A, Hilary and T. Kelly, Kate, Sara S, Sara D, and many others. And family: Charles, Angela, and Alex. Michael, Liza, James, Kate, Mary Ellen, Laura; Jeanne, John, Karen, Bob, Grandpa ...

I'm sorry for forgetting others this moment. I will buy you four drinks.

JOSEPH KECKLER is a singer, musician, writer, and artist. He performs widely and has appeared at venues such as Lincoln Center, Brooklyn Academy of Music, SXSW, Miami Art Basel, and Centre Pompidou. He is the author of several plays and many songs, and has written about contemporary art for *VICE* and other publications. His work has been featured on WNYC and BBC America, and he has received a number of awards, including a Creative Capital grant and a fellowship from New York Foundation for the Arts. *Dragon at the Edge of a Flat World* is his first book.

Printed in the USA
CPSIA information can be obtained
at www.ICGtesting.com
JSHW021218140324
59231JS00002B/10